READY TO PAINT

Watercolour
Rivers & Streams

Keith Fenwick

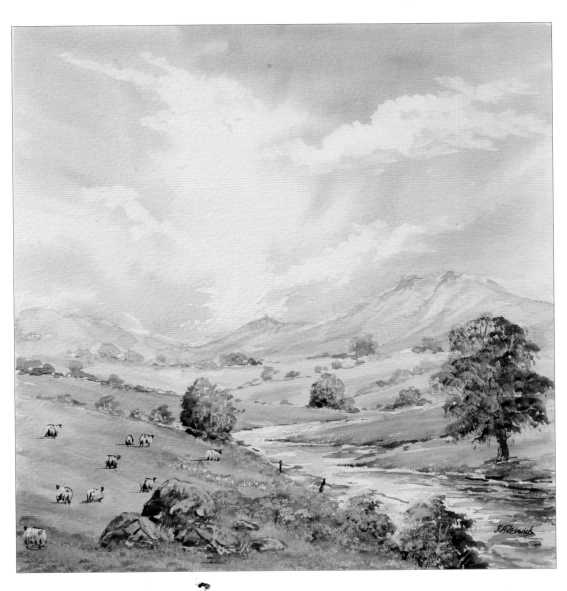

SEARCH PRESS

First published in Great Britain 2010

Search Press Limited
Wellwood, North Farm Road,
Tunbridge Wells, Kent TN2 3DR

Reprinted 2012

Text copyright © Keith Fenwick, 2010

Photographs by Debbie Patterson at Search Press Studios

Photographs and design copyright © Search Press Ltd, 2010

All rights reserved. No part of this book, text, photographs or
illustrations may be reproduced or transmitted in any form or by
any means by print, photoprint, microfilm, microfiche, photocopier,
internet or in any way known or as yet unknown, or stored in a retrieval
system, without written permission obtained beforehand from
Search Press.

ISBN: 978-1-84448-479-9

The Publishers and author can accept no responsibility for any
consequences arising from the information, advice or instructions given
in this publication.

Readers are permitted to reproduce any of the tracings or paintings in
this book for their personal use, or for the purposes of selling for charity,
free of charge and without the prior permission of the Publishers.
Any use of the tracings or paintings for commercial purposes is not
permitted without the prior permission of the Publishers.

Suppliers
If you have any difficulty obtaining any of the materials and equipment
mentioned in this book, please visit the Search Press website:
www.searchpress.com

You are invited to visit the author's website at
www.keithfenwick.co.uk

Publisher's note
All the step-by-step photographs in this book feature the author,
Keith Fenwick, demonstrating watercolour painting techniques.
No models have been used.

**Please note that when removing the perforated sheets of tracing paper
from the book, score them first, then carefully pull out each sheet.**

Page 1
Spring Time
29 x 30cm (11½ x 11⅞in)

*This soft, pastoral scene makes a pleasing composition, with the
river providing good linear perspective that leads the eye into the
recessive mountain range.*

Opposite
Fishing on the Dart

25.5 x 33cm (10 x 13in)

*A tranquil scene exhibiting a wide range of greens. The rocks
are a feature in this composition. Note the variety of subtle
colours and textures displayed on the rocks. The white water
was created with the use of masking fluid.*

Printed in China

Dedication
This book is dedicated to all the people who watch
me paint at shows, who work with me on my painting
holidays and watch my television programmes.
They have taught me what they expect from a book
and I am forever grateful for their support.

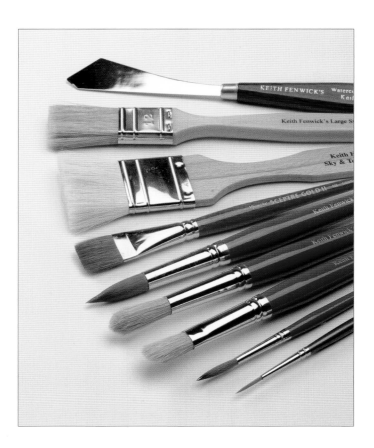

Acknowledgements
I would like to thank Roz Dace for the opportunity
to create this book, Edd my editor for his advice
and patience and Debbie for her wonderful
photographic skills.
A big thank you to Martin at Winsor & Newton for
providing the paints and paper that have been used
throughout this book.
Last but not least to my wife and personal assistant
for putting up with me and keeping my feet on
the ground.

Contents

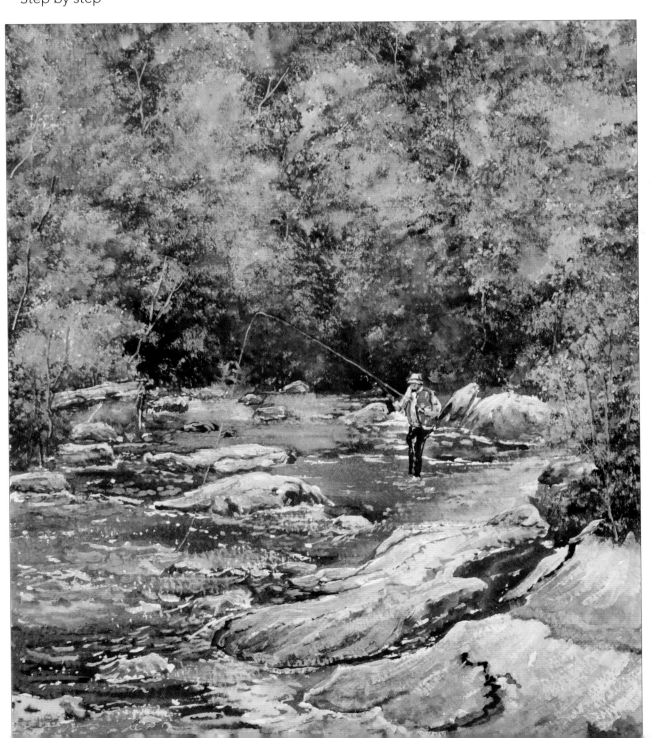

Introduction

History shows that rivers and streams have played an important role in the social and cultural life of most societies. They have provided power for industrial use and water for human consumption and leisure for generations. As an artist, I feel a part of nature when I sit alongside a river, stream or mountain beck attempting to capture the atmosphere and mood of the landscape in paint. I'm in heaven listening to the sound of running water and if I'm quiet, I may even enjoy the company of the local dipper, heron or duck.

When I am demonstrating at one of the many major shows or running a painting holiday or painting outdoors, people often tell me that they have always wanted to paint but don't know how to get started and do not have the gift. I do not believe that painting is a 'gift'. With over thirty years of experience teaching people to paint, I can assure you that you will be able to paint, providing that you are prepared to work at it. The more hours you spend practising, the more 'gifted' you will become.

This book provides you with an exciting variety of rivers and streams to paint over the different seasons. I have chosen five achievable landscape paintings for you to complete, some simple, some more detailed representations. The aim of this book is to encourage you to paint a landscape without having to spend years learning the basics. Painting is not brain surgery, it's just a matter of following a series of simple steps. It is like putting a jigsaw together, piece by piece. Let me assure you that anyone can be taught to paint; you can do it, if you really want to.

I have provided you with a tracing for each project plus an extra one for you to try. Simply follow the stage-by-stage instructions provided and the useful tips given and you will be able to complete similar paintings. In some of the tracings, I have sketched in cloud formations and indications of water flow patterns but it is not expected that you follow these suggestions exactly. The amount of detail you paint is your choice, and I want you to have fun and enjoy yourself, not worry about small details.

Learning to paint is fun and it will change your life – ask any artist. You will learn to see aspects of the landscape you never noticed before and fully appreciate the wonders of nature. Remember that practice makes perfect, winners never quit and quitters never win. So let's get out those brushes and paints and have some fun together. I know you can do it.

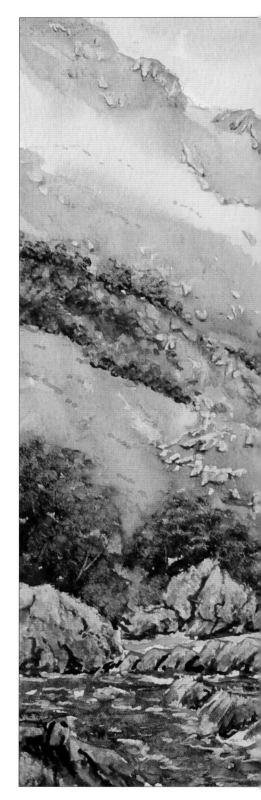

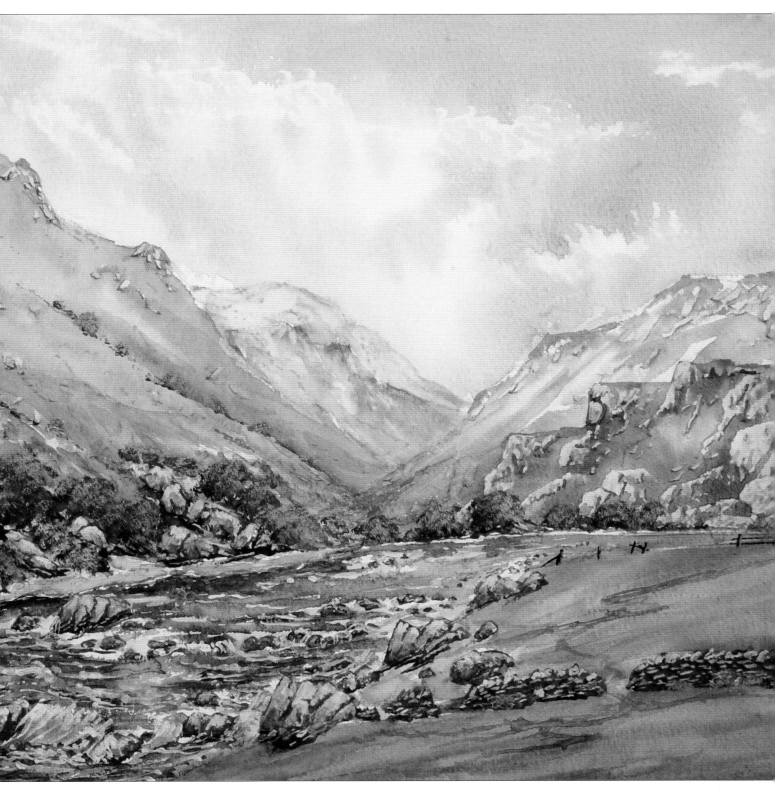

Rocks and Running Water, Scotland

42 x 29cm (16½ x 11½in)

A bonus tracing for this painting is provided in this book. The fast-flowing river leads the eye into the distant mountains. Note the range of subtle colours in the mountains, painted wet-into-wet.

Materials

Paints

I always recommend purchasing the best quality paints you can afford. I prefer to use Artists' Quality watercolours as they contain more pigment than Students' Quality watercolours. They are more expensive to purchase but they also last longer.

You do not need to buy dozens of colours as you can mix a wide range of colours and shades using a few tubes. I always use tube colours rather than pans of paint as I want fresh moist colour and it is so much easier to mix large washes.

My preferred palette of colours:

Sky colours: Payne's gray blue shade, cobalt blue, alizarin crimson.

Earth colours: Raw sienna, burnt sienna.

Mixers: Sap green, cadmium yellow light, cadmium orange.

Occasional colours: Vermilion, lemon yellow.

To create highlights, I mix a little acrylic titanium white into my traditional watercolours.

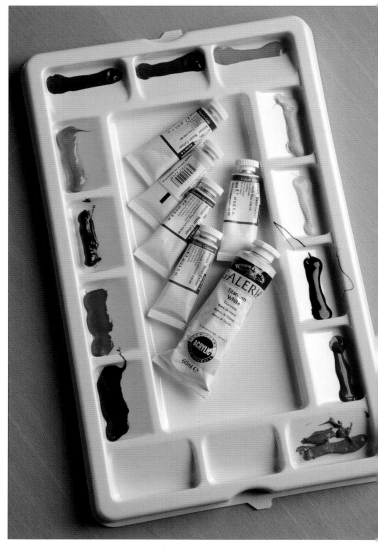

Artists' quality watercolour paints laid out in Keith Fenwick's Professional Palette. The palette has a lid with six large mixing areas, allowing access for the larger Sky and Texture brush.

Paper

Paper can be purchased in different weights, from 190gsm (90lb) weight – the thinnest – through 300gsm (140lb), 425gsm (200lb) and 630gsm (300lb) weights – the thickest papers. There are also different surfaces, each with different properties that should be borne in mind when painting.

HP – Hot pressed paper has very little surface and is principally used for drawing or pen and wash where a rougher surface would cause some spatter.

CP/NOT – Cold pressed/not paper has a rougher surface than HP paper.

ROUGH – Rough or very rough paper is my preferred choice as the more pronounced texture provides a surface that allows special effects to be achieved such as sparkle on water and texture on trees. For the beginner this surface helps to control the flow of paint.

All of the paintings in this book were painted on Bockingford rough-surfaced 300gsm (140lb) paper.

Brushes and palette knife

I have created my own range of brushes to suit my needs and to simplify painting. With this set of brushes I am able to paint any landscape I encounter, be it in watercolour, oil or acrylics. They have been developed over many years, to simplify the painting of landscapes, enabling beginners and less experienced painters to paint a professional-looking landscape with minimal effort and satisfying results.

The **size 14 round** brush holds a lot of paint and has a fine point. It is a sable/synthetic mix and I use it for painting water, distant trees, edging river banks, clouds and mountain structures. I very rarely use the point of a brush, rather I use the side of it to apply washes of colour. By fanning this brush between thumb and forefinger I can create the shape of a fan brush for painting grasses.

The **size 6 rigger** brush is also a mix of sable and synthetic hair and is used for finer detail and scumbling to create shadows, texture on mountains, figures etc. The **size 3 rigger** brush is used when I need to paint fine detail – such as twigs, fence posts, fissures in rocks and shadows in snow, etc.

The **20mm (¾in) flat** brush is a sable/synthetic mix that holds a lot of paint. It is used to shape rocks, cliffs, buildings and windows, and also to rough out the

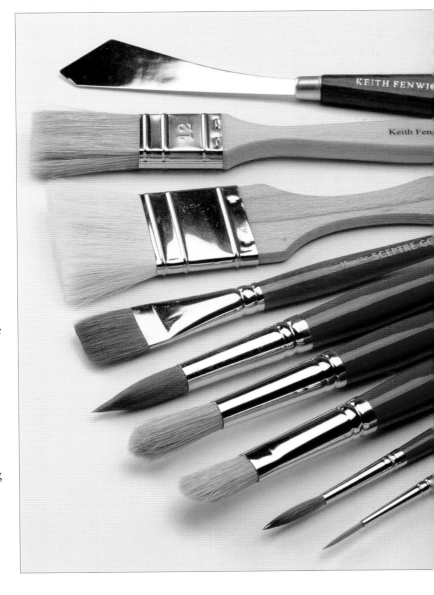

The brushes used in this book. From top to bottom: Wonder Knife, large stippler, Sky and Texture brush, 20mm (¾in) flat brush, size 14 round, Derwentwater, Ullswater, size 6 rigger, size 3 rigger.

shape of fir trees and other structures. The **Sky and Texture brush** is a 40mm (1½in) hake brush made from fine hair. It is twice as thick as a conventional hake, enabling it to hold lots of fluid and designed to come to a chisel edge to edge river banks and so forth. It was created to simplify the painting of skies and grass areas, and also to create texture in snow and sparkle on water.

The **large stippler** brush is a 25mm (1in) brush and used to paint foliage on trees and texture in the landscape when needed. Special textures can be created simply stippling.

The Unique Tree Foliage and Foreground brushes are a set of two brushes I have developed to make the painting of the foliage, texture and wild flowers in grass areas etc. simple but effective. The **Derwentwater** brush has a round domed end and is used by stippling, to rough out tree shapes and to add the fine detail representing foliage on trees. I use it to paint areas of bluebells, wild flowers, texture on rocks etc. The **Ullswater** brush has a chisel edge used where more shape is required such as when painting fir trees, Scots pines, cypress trees, ivy growing on trees, bluebell woods, foregrounds and tufts of grass – wherever I need shape.

In addition, I use my **Wonder Knife**, a specially shaped palette knife, electroplated to prevent rusting and very light and flexible. I use it for moving paint to create mountains, stone walls and tree structures. It has simplified my painting, allowing me to create realistic effects that can not easily be replicated with a brush.

Other materials

A **hairdryer** is used to speed up the drying time between stages.

Masking fluid is used to preserve parts of the paper required to be uncovered when applying the initial washes.

20mm (¾in) **masking tape** is used to control the flow of paint – for example stretched across the painting to represent the horizon, enabling colours to be painted down to this level. I use 20mm (¾in) tape rather than 25mm (1in), as it can easily be bent to represent the uneven top of a field etc.

Water-soluble crayons are ideal for adding highlights on rocks and for drawing. I use a white crayon for highlights and correcting mistakes and a dark brown one for drawing. Ensure they have fine points using a **pencil sharpener**.

Paper tissues are useful for removing paint to create cloud formations, highlights on rocks and other techniques. They must be absorbent.

I use a specially designed partitioned **water pot** as I work. One part of the pot is used to hold and rinse the brushes and the other is used to hold clean water for use on the painting itself.

I use a quality metal **easel** when working outdoors and a table easel when working indoors. When demonstrating at shows or painting a large canvas I use a Phantasm Metal Easel that I have modified so it becomes a complete work station rather than just an easel.

A **putty eraser** can be useful for removing large areas of masking fluid if required, though I normally use my finger as it never gets lost.

Sponges are useful for washing out areas of paint to suggest effects such as shafts of light, or for stippling to create foliage, bluebells or other interesting textures.

A **painting apron** is useful to keep splashes of paint off clothing.

I use a piece of card as a **mask** to control the deposit of paint. Any piece of card – or an offcut of watercolour paper – will suffice.

The **Keith Fenwick Professional Palette** I use is shown on page 6. It has a lid that has six large mixing areas for large washes.

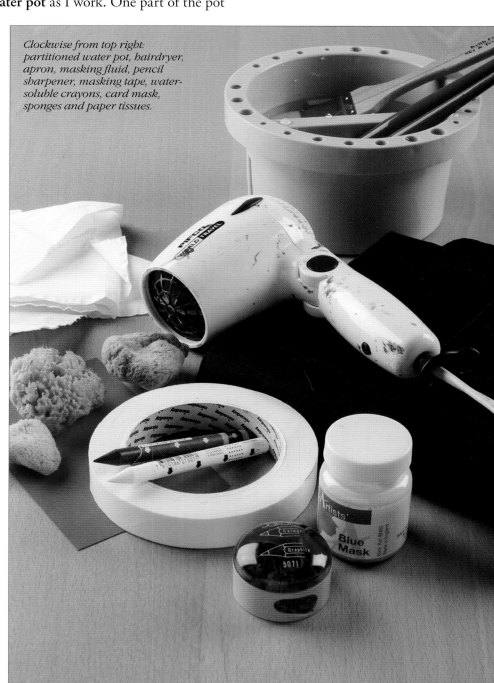

Clockwise from top right: partitioned water pot, hairdryer, apron, masking fluid, pencil sharpener, masking tape, water-soluble crayons, card mask, sponges and paper tissues.

Transferring the image

Tracings are provided at the front of this book for all the demonstration paintings, and a bonus tracing of the picture on pages 4–5 is also included. Follow the steps shown below to transfer the images on to watercolour paper. You can reuse each tracing several times so you can use the same basic image to produce two quite different paintings. Extract the tracing you wish to use from the front of the book and follow the instructions below to transfer the image to your watercolour paper. I have used a ballpoint pen to transfer the image. A burnishing tool or other pointed object would also work.

Tip

These are my secrets of watercolour painting:

- The wetness of the paint on the brush in relation to the wetness or dryness of the underpainting is important, as is correctly timing when to apply the paint.
- To ensure freshness in the painting, use the largest brush, in relation to the size of the element, that you can.
- Use the minimum number of brush strokes to avoid colour mixing on the paper.
- Before mixing paint, thoroughly wet the hairs of your brush. Remove surplus water from the hair then use circular movements of the brush to draw the desired amount of pigment away from the deposit of paint.
- Always hold a tissue in your opposite hand to remove surplus paint from your brush, as required.

1 Place your tracing face down on some scrap paper. Go over the lines on the back using a soft pencil (4B or 6B.) I prefer to use a dark brown water-soluble crayon because once the image has been transferred, the coloured lines will wash out as the painting progresses. I do not like to see pencil lines on a painting.

2 Tape your sheet of A3 size watercolour paper to your board and place the tracing face-up on top. Fasten the top of the tracing using only masking tape. Use a ballpoint pen to go over the lines to transfer the image.

3 As you work, regularly lift up the tracing, ensuring the image is being satisfactorily transferred. When the transfer is complete, remove the tracing and you are ready to paint.

New Forest Stream

This is a simple stream flowing through the fields. It has no clearly defined banks and the subject matter makes a simple but attractive composition. Note how the inclusion of a few posts and the addition of a little bird life improves the composition.

TRACING
2

You will need

300gsm (140lb) rough watercolour paper, 44.5cm x 32.6cm (17½ x 12¾in)

20mm (¾in) masking tape

Dark brown and white water-soluble crayons

Card mask

Colours: Payne's gray, cobalt blue, alizarin crimson, raw sienna, burnt sienna, cadmium yellow, lemon yellow, sap green, titanium white acrylic

Brushes: Sky and Texture brush, size 14 round, large stippler, Derwentwater and Ullswater brushes, size 6 rigger, size 3 rigger

Keith Fenwick's Wonder Knife

Paper tissues

1 Transfer the image to the paper, following the instructions on page 9. Secure the paper to a board with masking tape. Use the Sky and Texture brush to wet the paper with a wash of dilute raw sienna across the whole sky.

2 Rinse the brush, and while the wash is wet, add in a cobalt blue wash wet-in-wet.

3 Lift out clouds using tissue paper, dabbing the paper on to lift away some of the paint, not rubbing. Keep turning the paper, so that you are always using a clean part of the paper for this. Allow to dry thoroughly.

Tip

Always keep a piece of clean tissue in your hand so that you can remove surplus paint from your brush if required.

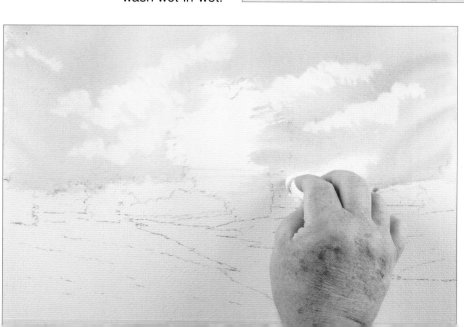

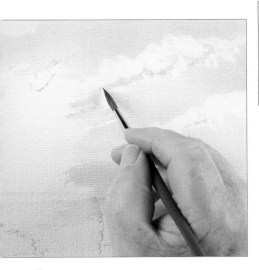

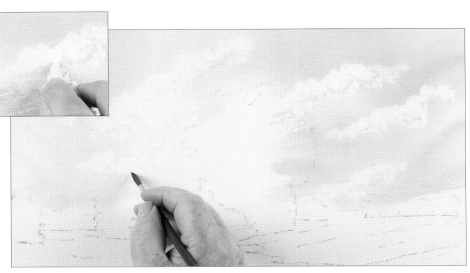

4 Switch to the size 6 rigger and add shadows to the clouds using a dilute mix of cobalt blue with a hint of alizarin crimson.

5 Twist some clean tissue into a point and use it to lift out some of the wet paint from the bottom of the cloud to soften it (see inset). Add shadows to the rest of the clouds, softening them with clean tissue as you work.

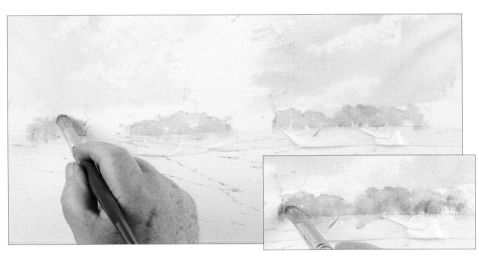

6 Position a piece of masking tape over the horizon. Start at the left and shape it as you work to follow the line of the tracing. Press down on the top of the tape to prevent the paint running down.

7 Mix cobalt blue with a touch of sap green. Using the Derwentwater brush, stipple in the distant trees. Add a little more sap green and Payne's gray to the mix and repeat along the base, to add more depth to the foliage (see inset).

8 Allow to dry thoroughly and then carefully remove the masking tape (see inset). Using the Sky and Texture brush, paint in the grassy bank on the right with a mix of cadmium yellow and sap green. Start at the top of the field and work down to the river.

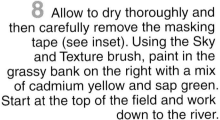

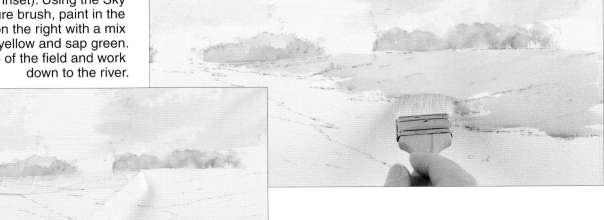

11

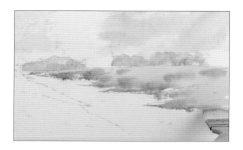

9 Add more sap green and raw sienna to the mix and use the chisel edge of the brush to shape the riverbank.

10 Adding more Payne's gray to the mix and using the chisel edge again, develop the riverbank further.

11 Switch to the size 14 round brush, blend the colours together with light, twitching strokes. While it is still wet, lift out some highlights with tissue.

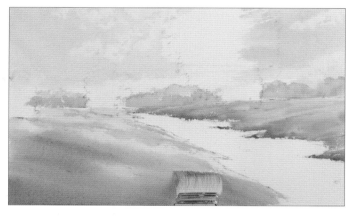

12 Repeat on the other bank, laying in the sap green and cadmium yellow mix with the Sky and Texture brush, and blending the colours together.

13 Add Payne's gray to the mix and use the tip of the brush to twitch in some darker grasses.

Note

I like to think of painting like the theatre expression: 'design the set, arrange the elements, and then light it'. These early stages establish the basic painting.

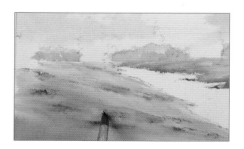

14 Use the side of the size 14 round brush to blend in the colour and soften the hard lines a little.

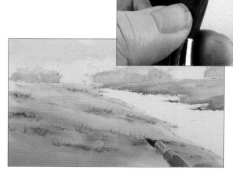

15 Mix sap green, Payne's gray and raw sienna. Spread the hairs of the size 14 round brush to create the shape of a fan (see inset) and flick in some lighter grasses.

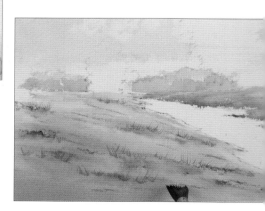

16 Turning the brush over, stipple in a few ridges to signify the lay of the land.

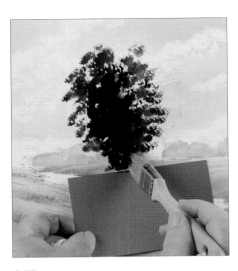

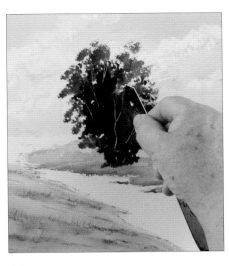

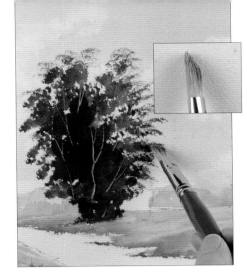

17 Switch to the large stippler brush. Create a dark mix of Payne's gray, sap green and burnt sienna, and stipple in the profile of the central tree. Use the card mask to protect the grass at the bottom as shown.

18 Scrape out the suggestion of branches using the Wonder Knife.

19 Switch to the Ullswater brush and use the chisel-shaped tip (see inset) with the same mix to shape the tree a little more.

Tip

Stippling is dabbing lightly to create a broken effect. I like to think of it as crushing midges!

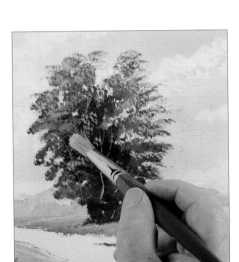

20 Using the Derwentwater brush, loaded with a mix of cadmium yellow, sap green and a touch of titanium white acrylic, stipple to create the effect of tree foliage.

21 Add more cadmium yellow to the mix and use the same stippling technique to create highlights. Allow to dry thoroughly.

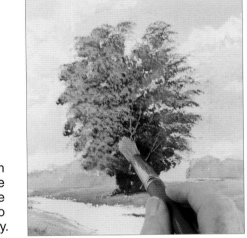

22 Using the same brush with a mix of sap green, a touch of cadmium yellow and a touch of titanium white acrylic, paint in the ivy at the bottom of the tree. Add a little more white and create highlights on the ivy (see inset).

23 Paint the other trees in the same way.

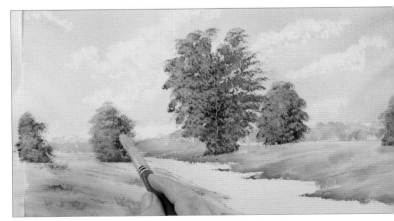

13

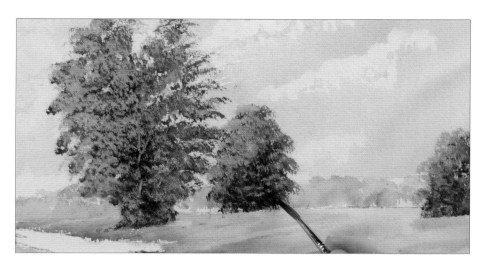

24 Switch to the size 6 rigger brush, and make a mix of one-fifth alizarin crimson and four-fifths Payne's gray, creating a deep purple shadow colour. Use this to add depth to the tree foliage. Apply the paint by wiggling the rigger.

Tip

The light is coming from the upper left, so the shadows should be concentrated on the lower right.

25 Change to the Derwentwater brush and a mix of lemon yellow, a hint of sap green and a little titanium white acrylic to add a few more highlights to contrast with the shadow colours. Using these mixes and brushes, harmonise the trees in the background with a few touches. Use the cardboard mask to protect the horizon.

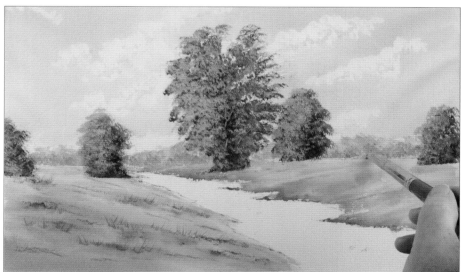

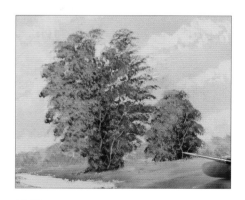

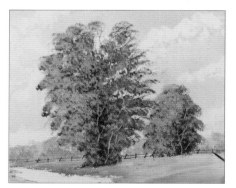

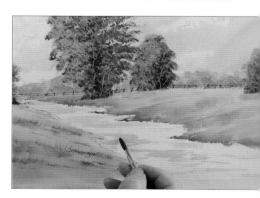

26 Use the size 3 rigger with a mix of titanium white acrylic and a hint of raw sienna to add branch structures to the foreground trees. Rest your hand on a dry area of the painting and flick the brush lightly to draw clean lines.

27 Mix Payne's gray and burnt sienna, and staying with the size 3 rigger, paint in the fence and more branch structures.

28 Using the size 6 rigger brush with cobalt blue, paint in the stream using horizontal strokes: light in tone in the background and darker towards the foreground.

Tip

It is important when painting fences that we do not paint them square. The distance between the fenceposts should be approximately twice the height of the fence.

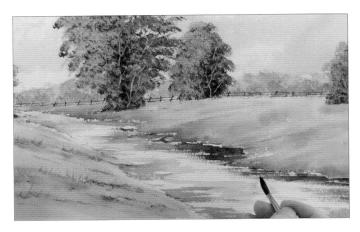

29 Add Payne's gray and a touch of alizarin crimson to the cobalt blue and add depth to the river, working inwards from the bank.

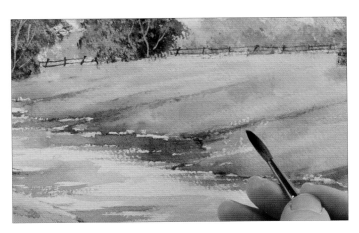

30 Using the same brush and mix, twitch the colour upwards into the grass. Use the natural breaks in the bank as a guideline.

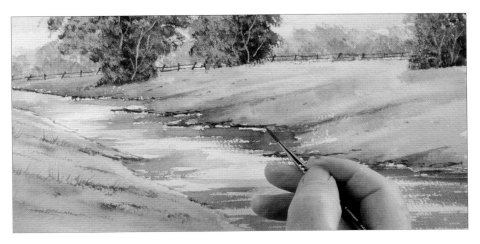

31 Mix in Payne's gray and burnt sienna to the mix and define the waterline along the banks with dots and dashes. Allow to dry thoroughly.

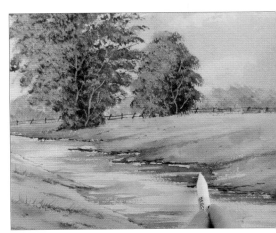

32 Using the white water-soluble crayon, soften the walls of the riverbank with horizontal strokes.

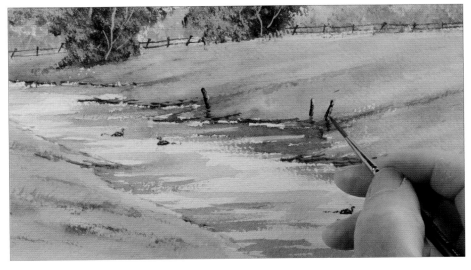

33 Using the size 14 round with a watery mix of raw sienna, apply a warm glaze over parts of the grass to add sparkle to the bank. Add in a few coots and fenceposts with a mix of Payne's gray and burnt sienna. Allow to dry, then remove the masking tape securing the painting to the board.

Tip

To add coots or ducks, simply draw the top of a circle and add a neck. Small details likes this can have a significant effect on the composition of the painting.

Overleaf

The finished painting.

15

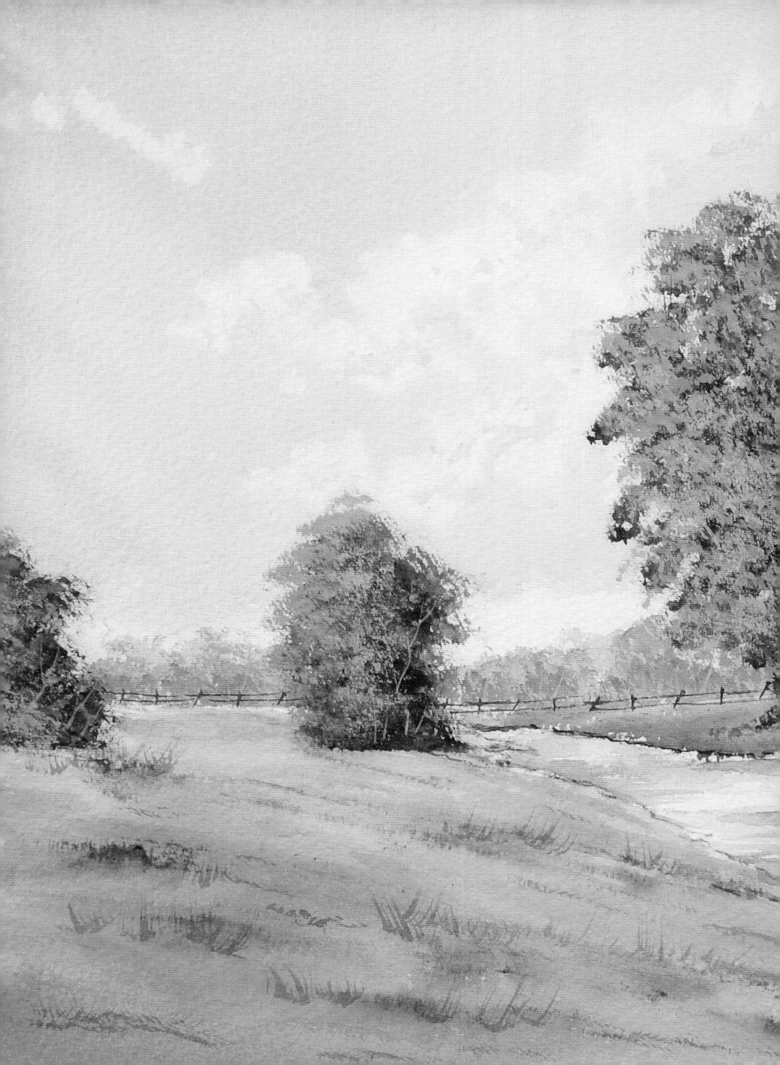

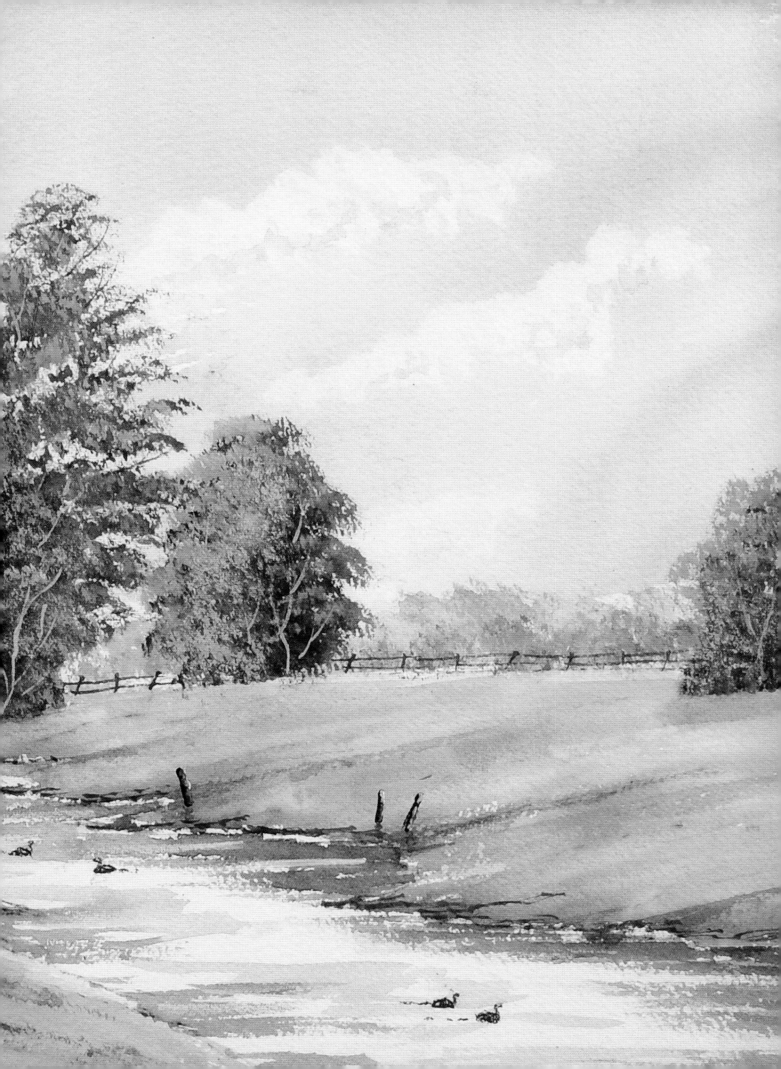

Bridge Over Stream

This is one of my favourite scenes to paint. Here it is painted as a winter scene, with a colourful evening sky to contrast with the snow-covered distant mountains and foreground. Take the opportunity to practise painting fast-flowing water. I have included a few Lakeland sheep to add interest.

TRACING
3

You will need

300gsm (140lb) rough watercolour paper, 44.5cm x 32.6cm (17½ x 12¾in)

20mm (¾in) masking tape

Masking fluid

Dark brown water-soluble crayon

Colours: Payne's gray, alizarin crimson, raw sienna, burnt sienna, titanium white acrylic, cobalt blue

Brushes: Sky and Texture brush, size 14 round, 20mm (¾in) flat, size 6 rigger, size 3 rigger, Derwentwater brush

Keith Fenwick's Wonder Knife

Paper tissues

1 Transfer the tracing to the paper as shown on page 9, then secure the paper to a board with masking tape and apply masking fluid to the areas shown.

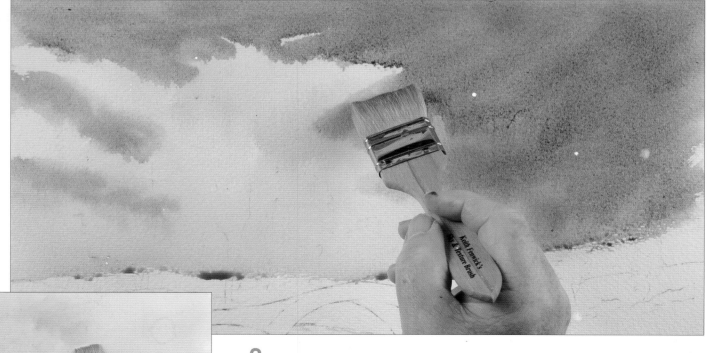

2 Wet the paper, by applying a raw sienna wash across the sky using the Sky and Texture brush (see inset), then add a dilute mix of Payne's gray and alizarin crimson wet-in-wet, avoiding the clouds in the centre.

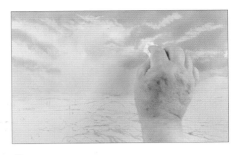

3 Lift out clouds using a clean paper tissue. Remember to turn the tissue so that it is always clean and dry when you touch the paper.

4 Position some 20mm (¾in) masking tape around the perimeter of the bridge.

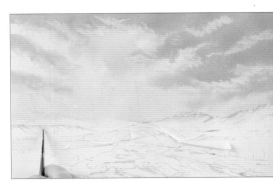

5 Use a mix of Payne's gray and alizarin crimson and the size 3 rigger to paint in the snow-capped mountains. Dab the paint on, then use the side of the brush to draw the colour down the mountains. Pick out a few outcrops in the same way.

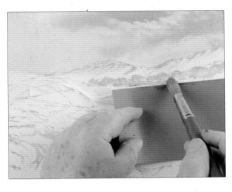

6 Using a piece of card as a mask and the Derwentwater brush, paint in some distant trees using the same mix as the mountain peaks.

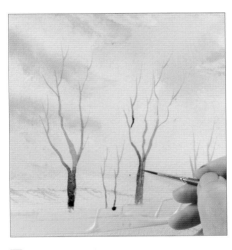

7 Change to the size 3 rigger and using a mix of Payne's gray and burnt sienna, paint in the foreground trees.

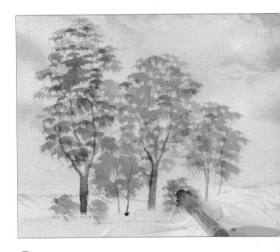

8 Using the Derwentwater brush and a mixture of Payne's gray and burnt sienna, stipple in the tree foliage.

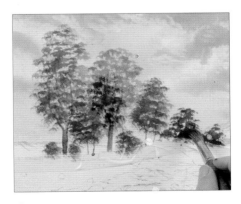

9 Continue to create the tree structures in the same way, adding depth to the foliage by adding more Payne's gray to darken the existing mix. Work to the right, painting in the additional trees across the bridge.

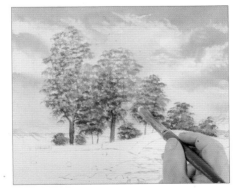

10 Remove the masking tape carefully, then use the Derwentwater brush and titanium white acrylic to lightly stipple the foliage, creating the impression of snow.

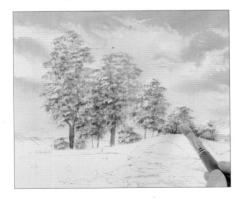

11 Using some clean titanium white acrylic, add some highlights to the foliage.

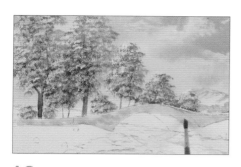

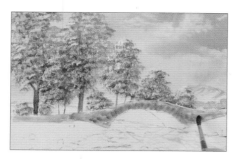

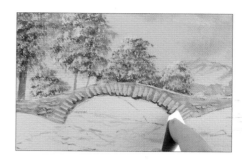

12 Use the size 6 rigger brush to paint in the stone wall and bridge with a raw sienna wash. While the underpainting is still wet, add some touches of burnt sienna.

13 Add a purple mix of alizarin crimson and cobalt blue wet-in-wet, varying the mix with Payne's gray.

14 Create the structure of the bridge with the Wonder Knife, gently scraping out the shapes shown to suggest stonework.

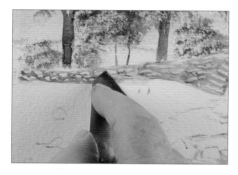

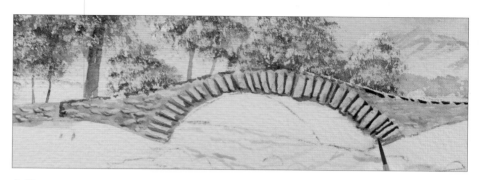

15 Wet the part of the wall on the left-hand side and create the impression of stonework with the Wonder Knife. As a guideline, the paint should be a third dry.

16 Using the size 3 rigger with a mix of Payne's gray and alizarin crimson, to make a deep purple, edge the stones on the bridge to create contrast with the highlights.

Tip

When adding shadows to stonework, only shade two sides: those furthest from the light source.

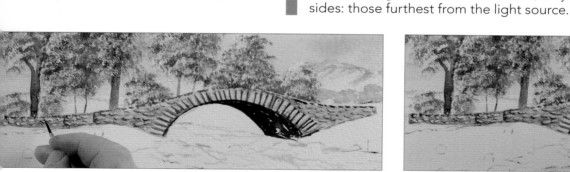

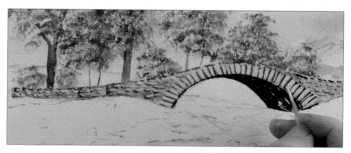

17 With the same mix and brush, paint in the arch, and paint in the shadows on the two sides of the stonework.

18 Using the size 3 rigger with titanium white acrylic and a touch of raw sienna, add highlights to the stonework on the bridge.

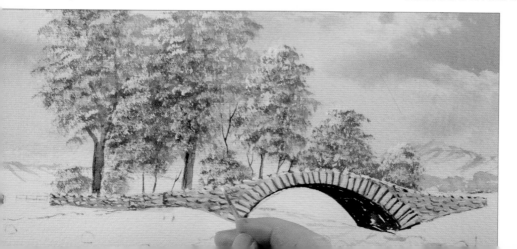

19 Using neat titanium white acrylic, paint in standing snow on the top of the bridge and wall. Add a few saplings above the bridge and between the larger trees in a contrasting mix of Payne's gray with a little alizarin crimson.

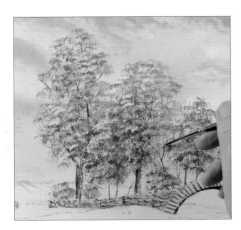

20 Still using the rigger, develop the branches and structure of the trees with the dark mix, and add some snow to the trunks with pure titanium white.

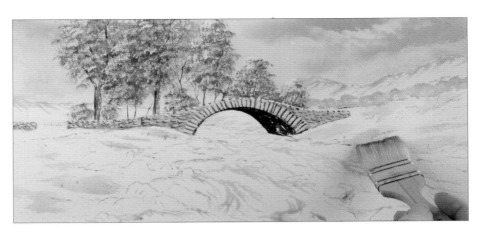

21 Use the Sky and Texture brush to paint in shadows on the snow. Use gentle strokes with a dilute cobalt blue mix with a hint of alizarin crimson.

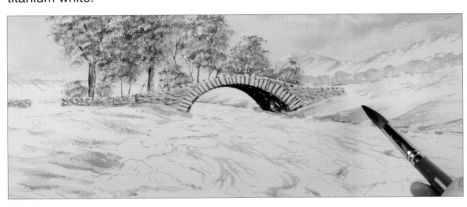

22 Using the size 14 round brush with a mix of Payne's gray and alizarin crimson, paint in the riverbank. Use the same mix to add subtle texture to the snow on the fields.

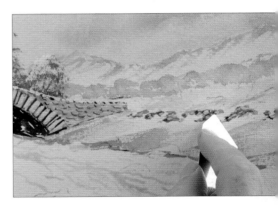

23 Mix burnt sienna with Payne's gray and paint in the broken-down stone wall on the right. Add more Payne's gray for shading, then move the paint with the Wonder Knife to create the impression of stonework.

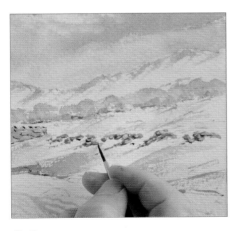

24 Shade the fallen rocks with Payne's gray and the size 3 rigger, then pick out the top of the field beneath the distant trees using a mix of Payne's gray and alizarin crimson.

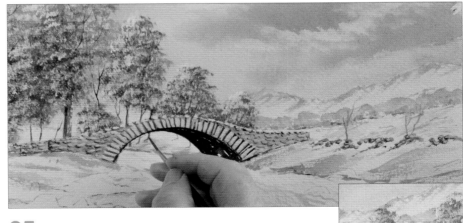

25 With a mix of Payne's gray and burnt sienna, paint in the young trees on the right and continue the trunks of the trees seen through the arch. Add foliage to the trees on the right using the Derwentwater brush, a mix of Payne's gray and burnt sienna and titanium white highlights (see inset).

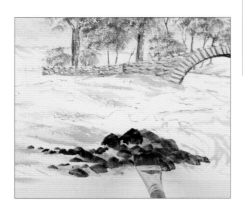

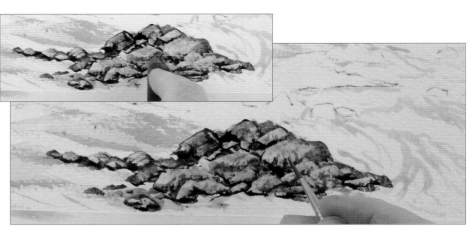

26 Using the 20mm (¾in) flat, apply raw sienna to the foreground rocks on the left. Add burnt sienna wet-in-wet, and follow that with a mix of alizarin crimson and Payne's gray, leaving parts of the previous colours uncovered.

27 Shape the rocks with the Wonder Knife (see inset). Use the size 3 rigger to add shadows with a mix of Payne's gray and alizarin crimson.

28 Using a similar technique, paint the remainder of the rocks.

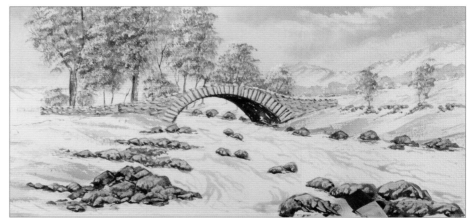

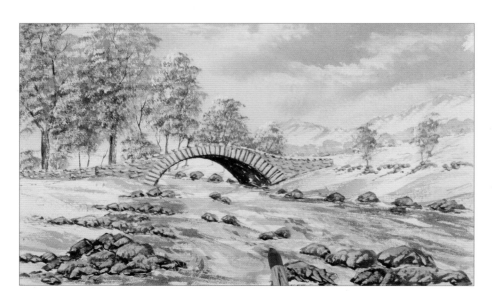

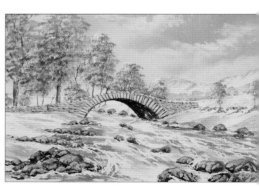

29 Using the size 14 round with a mix of cobalt blue and a little touch of alizarin crimson, paint in the water. The paint will be repelled by the masking fluid previously applied to the painting. Vary the colours with alizarin crimson and Payne's gray.

30 Allow the painting to dry thoroughly, then use a clean finger to rub away the masking fluid.

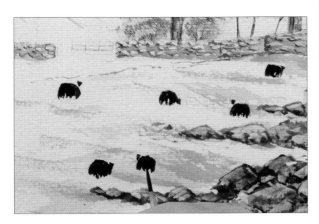

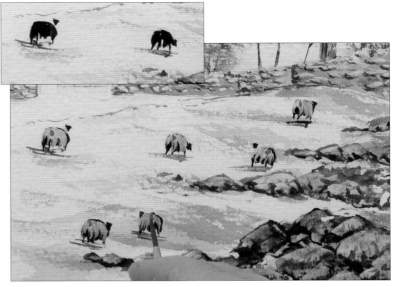

31 We will add the sheep at this point. Mix Payne's gray and burnt sienna and paint some horseshoe shapes on the left with the size 3 rigger. Add small triangles on the left or right to represent the heads of the sheep.

Tip

Make sure that the heads of the sheep are attached, or they get very upset!

32 It is important to add shadows that follow the lay of the land under the sheep. Add them with a dilute version of the same mix (see inset). Using titanium white acrylic paint the fleeces, then shade the fleece underneath with a little Payne's gray. Allow to dry, then highlight with a raw sienna and titanium white mix before adding a tiny red dot of alizarin crimson to each.

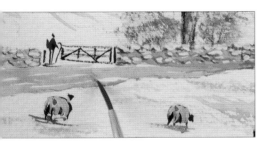

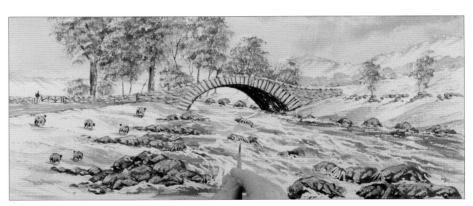

33 The next stage is to paint in the gate with Payne's gray and burnt sienna, then paint an upright lemon shape next to it. Add legs, backpack, head and a shadow with the same colours to represent Farmer Brown viewing his flock. With a mix of Payne's gray, cobalt blue and a little titanium white acrylic, paint in the road leading to the bridge.

34 It is now time to bring the painting together, so with the size 3 rigger and the same mix, add some dark details, such as the edge of the road, stubble in the field and shadows on the rocks. Add broken touches of cobalt blue to the water, along with titanium white where the river meets the rocks. These small details add realism to the painting of the landscape, and are very important.

35 Add some purple (a mix of alizarin crimson and Payne's gray) to the side of the bridge, then add some fenceposts along the riverbank with a mix of Payne's gray and burnt sienna. Paint a reflection of the underside of the bridge with the same mix. This has to be painted the full width of the bridge and not the shape you can see of the underarch. Allow the painting to dry completely and then remove the masking tape.

Overleaf

The finished painting.

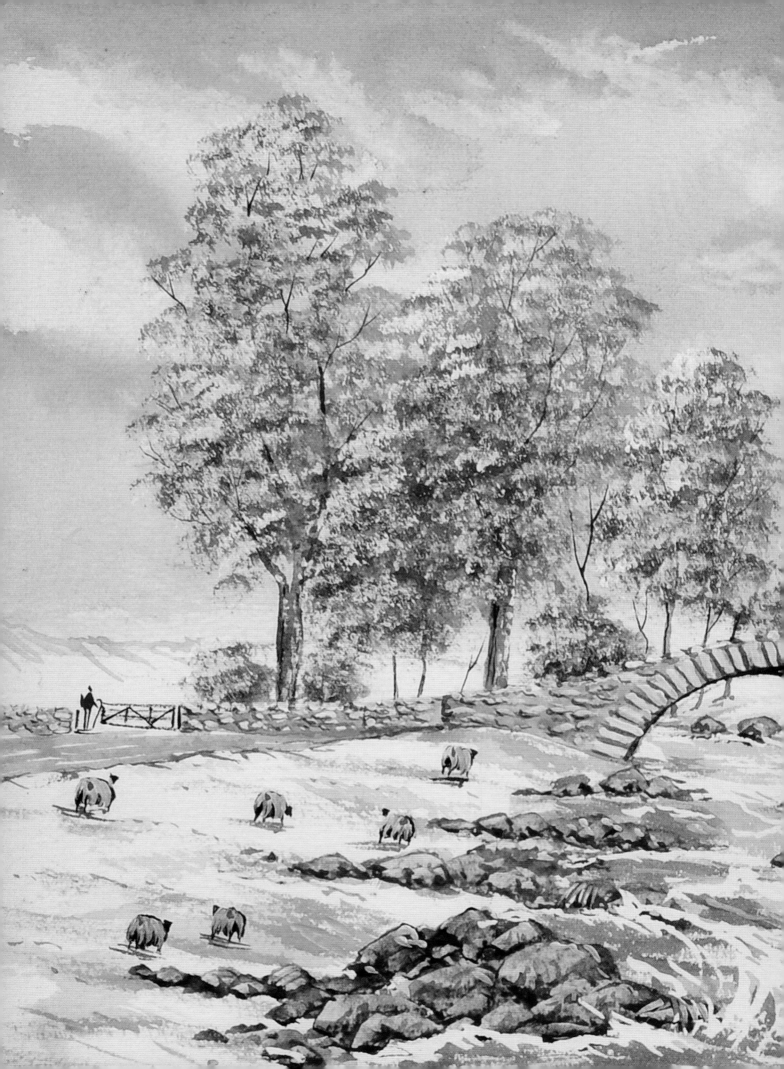

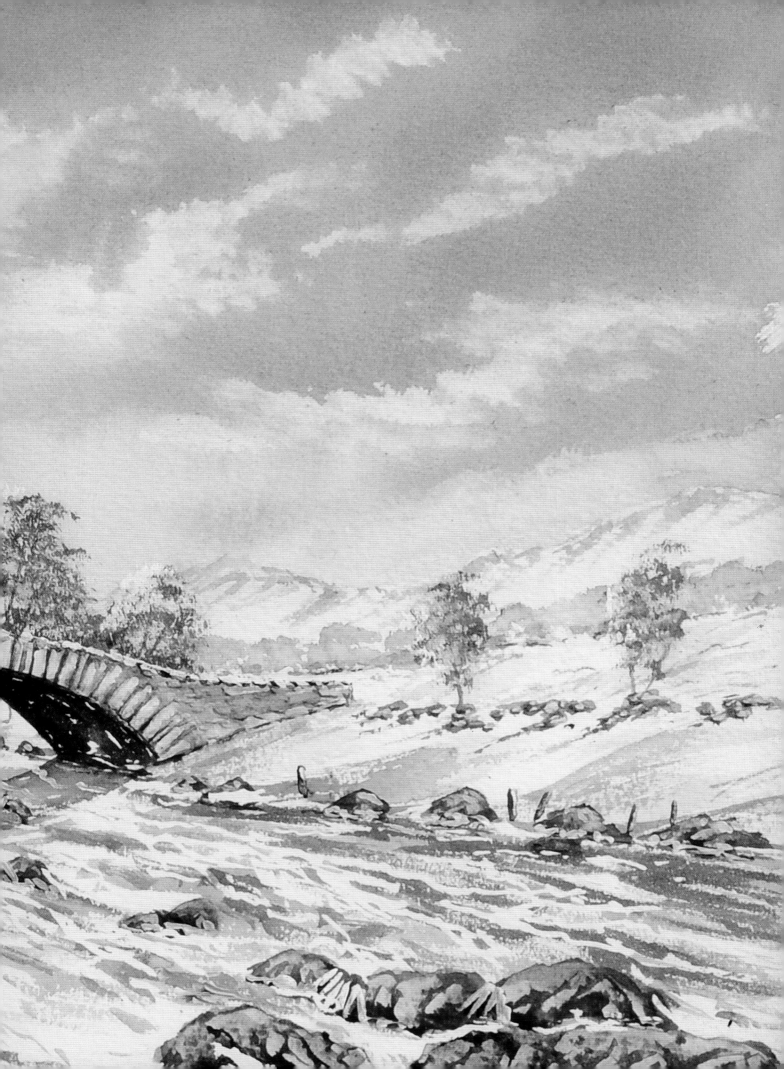

Welsh Gorge

Gorges like this are common in the Welsh landscape. The rugged rocky embankment and fast-flowing water over the rocks make a great composition. This painting provides an opportunity to experiment with colour mixing for the autumn foliage.

TRACING

You will need

300gsm (140lb) rough watercolour paper, 44.5cm x 32.6cm (17½ x 12¾in)

20mm (¾in) masking tape

Masking fluid

Dark brown and white water-soluble crayons

Colours: Payne's gray, cobalt blue, alizarin crimson, raw sienna, burnt sienna, cadmium yellow, lemon yellow, cadmium orange, sap green, vermillion, titanium white acrylic

Brushes: Sky and Texture brush, large stippler, size 14 round, Derwentwater brush, size 6 rigger, size 3 rigger, 20mm (¾in) flat

Keith Fenwick's Wonder Knife

Paper tissues

1 Transfer the image to the paper following the instructions on page 9, then secure it to your board with masking tape. Apply masking fluid to the water as shown.

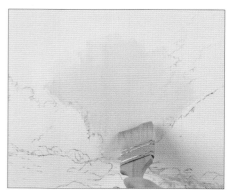

2 Use the Sky and Texture brush to apply a wash of a mix of raw sienna and cadmium yellow in the middle of the sky.

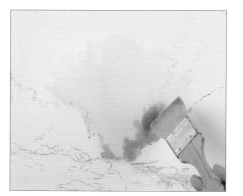

3 Quickly prepare a mix of cobalt blue and alizarin crimson and add touches in wet-in-wet near the ground level to represent background trees.

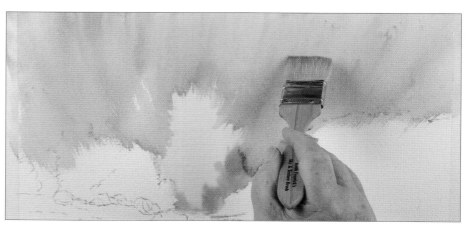

4 Wash in dilute cobalt blue in the rest of the sky, working from the edges of the painting into the yellow area. Allow to dry thoroughly.

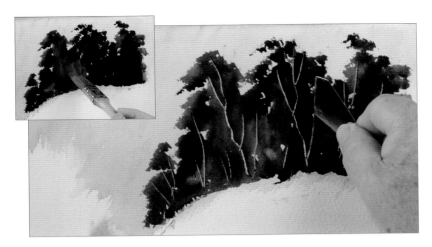

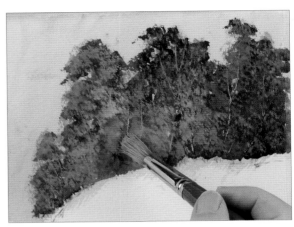

5 Using the large stippler, loaded with a mix of Payne's gray and sap green, paint in the background of the trees on the upper right (see inset). While the paint is wet, scratch in a few tree structures using the Wonder Knife.

6 Allow to dry thoroughly, then use cadmium yellow and cadmium orange with the Derwentwater brush to create the impression of foliage. Gently stipple the paint on with a light touch. Add sap green, vermillion and lemon yellow to your colours to complete the underpainting on the trees.

7 It is now time to add highlights. Combine the colours from the previous step with a little titanium white acrylic and repeat the stippling process.

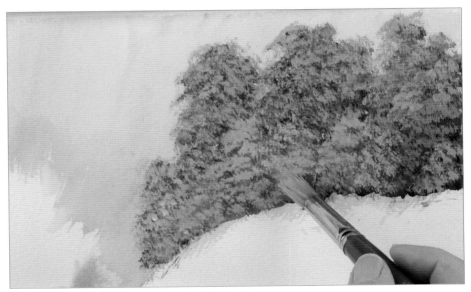

Tip

At this stage, the paint being applied should not be too wet. How the paint is being deposited will tell you whether the brush is sufficiently wet or not – aim to create the impression of foliage.

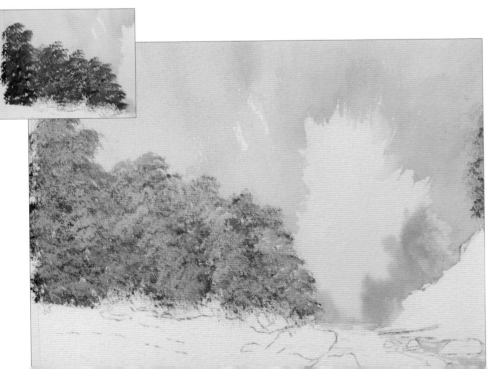

8 Paint the trees on the left in the same way, starting with the underpainting (see inset), then adding highlights.

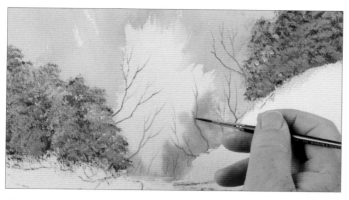

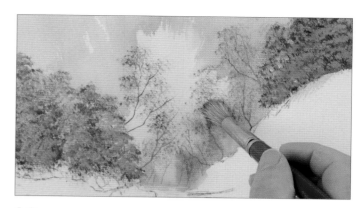

9 Use the size 3 rigger with a burnt sienna and Payne's gray mix to paint in some young trees to draw your eye towards the gap in the centre. Rest your hand on the paper and twitch the brush upwards to keep your lines fine and even.

10 Using the Derwentwater brush with reasonably dry raw sienna, stipple foliage on to the young trees. To darken the tone, add more burnt sienna. Stipple very lightly to deposit the areas of foliage.

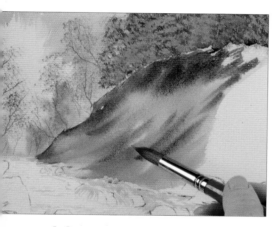

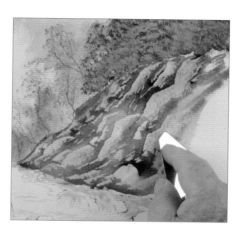

12 Use the Wonder Knife to create rock structures. Angle the knife as you reach the ground level to create the impression of the sloping angle of the cliff. It might help to think of the process as buttering your bread!

11 Lay in a raw sienna wash over the right-hand cliff face with the Sky and Texture brush; then add a purple mix of alizarin crimson and cobalt blue wet-in-wet, using the size 14 round brush. Develop this variegated wash with Payne's gray, lemon yellow and sap green.

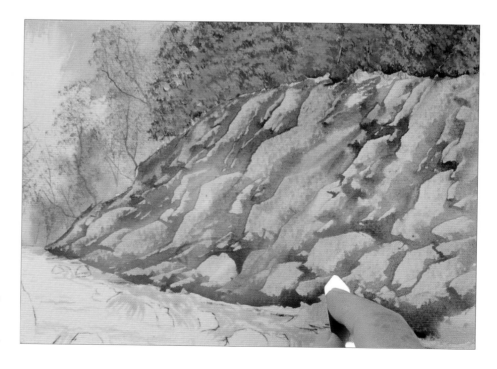

13 Paint the foreground area of the cliff in the same way, creating larger rocks by using progressively more of the edge of the Wonder Knife.

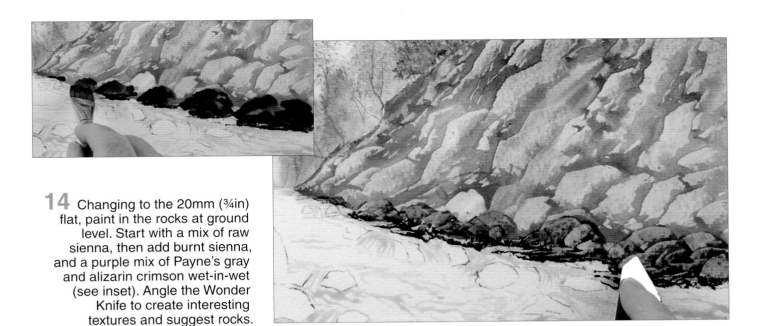

14 Changing to the 20mm (¾in) flat, paint in the rocks at ground level. Start with a mix of raw sienna, then add burnt sienna, and a purple mix of Payne's gray and alizarin crimson wet-in-wet (see inset). Angle the Wonder Knife to create interesting textures and suggest rocks.

15 Using the Sky and Texture brush, paint in the left-hand grassy bank with a mix of cadmium yellow and a little sap green. Add more sap green to vary the mix (see inset). Switch to the size 14 round and add some darker streaks in the foreground with a mix of sap green and burnt sienna. Use one of your knuckles to create texture in the grass, simply tapping it gently against the wet paint.

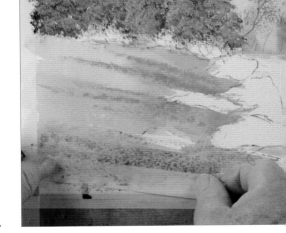

16 Lay a strip of masking tape over the wet paint in the foreground, then lift it away to create further texture.

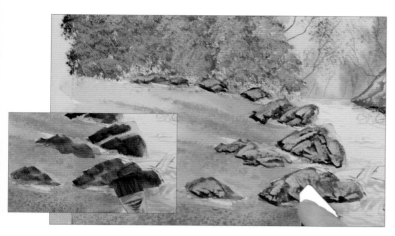

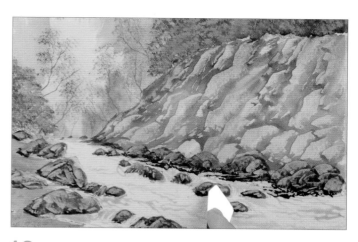

17 Paint the rocks on the bank with the 20mm (¾in) flat, initially applying a wash of raw sienna, then adding burnt sienna wet-in-wet, followed by a mix of Payne's gray and alizarin crimson. Leave some of the other colours showing through (see inset). Use the Wonder Knife to move the paint away to create texture.

18 Paint the rocks in the stream in the same way.

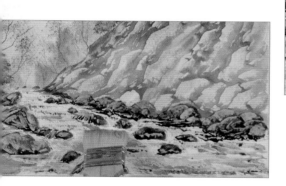

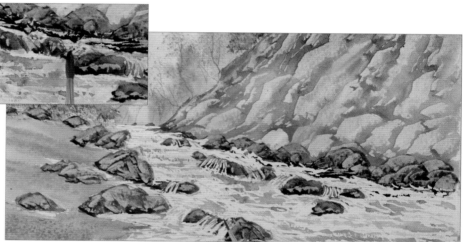

19 Dance across the water lightly with the Sky and Texture brush and cobalt blue, creating a dash-and-dot effect, then add Payne's gray to the blue and go over aspects of the water again.

20 Allow the paint to dry completely, then switch to the size 3 rigger to add touches of a darker mix of Payne's gray and cobalt blue between the rocks (see inset). Allow to dry, then use a clean finger to remove the masking fluid before adding a few more touches of cobalt blue with the size 3 rigger.

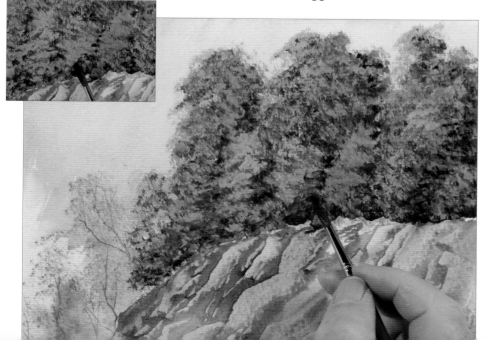

21 Using the size 6 rigger brush loaded with a mix of Payne's gray and alizarin crimson, add some depth to the trees. Trees are darker on the inside and bottom, so dab the paint on (see inset) before moving it around with the tip of the brush.

22 Repeat this procedure across the trees on the left, then use a mix of titanium white acrylic and a little raw sienna with the size 3 rigger to create tree structures and highlights across all the trees on the painting, including the trunks of the young trees.

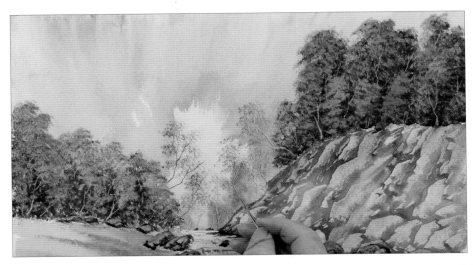

Tip

Keep the branches you paint in between fifteen and thirty degrees from vertical, as this looks more natural.

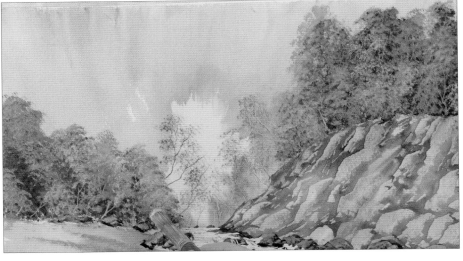

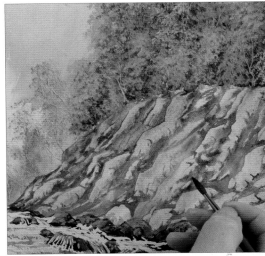

23 Paint the highlights on the foliage, using the Derwentwater brush with varied mixes of cadmium orange, vermillion and alizarin crimson to add an autumnal feel. Add a little titanium white acrylic and raw sienna mix for the highlights.

24 Mix Payne's gray with alizarin crimson for a dark shadow and use the size 6 rigger to add definition to the craggy cliff face on the right.

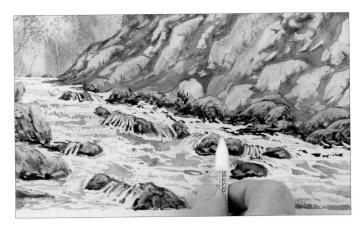

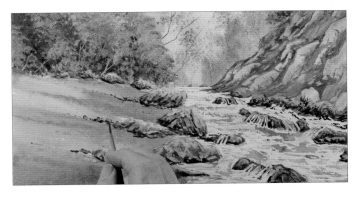

25 Using the size 3 rigger, add some structure to the rocks with raw sienna, burnt sienna and a darker mix of alizarin crimson and Payne's gray. Use a white water-soluble crayon for highlights.

26 Using cadmium yellow with the Derwentwater brush, add sparkle to the grassy areas. Allow to dry, then add touches around the rocks on the grass bank with a burnt sienna and Payne's gray mix to finish. Allow to dry and then remove the masking tape.

Overleaf

The finished painting.

31

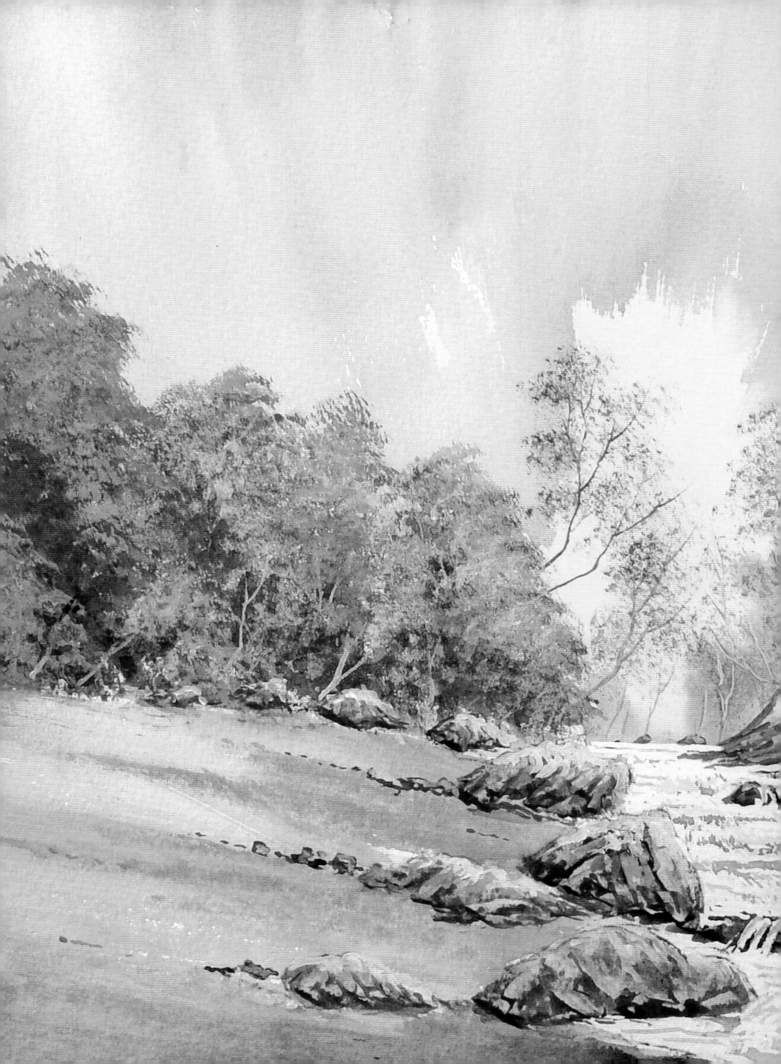

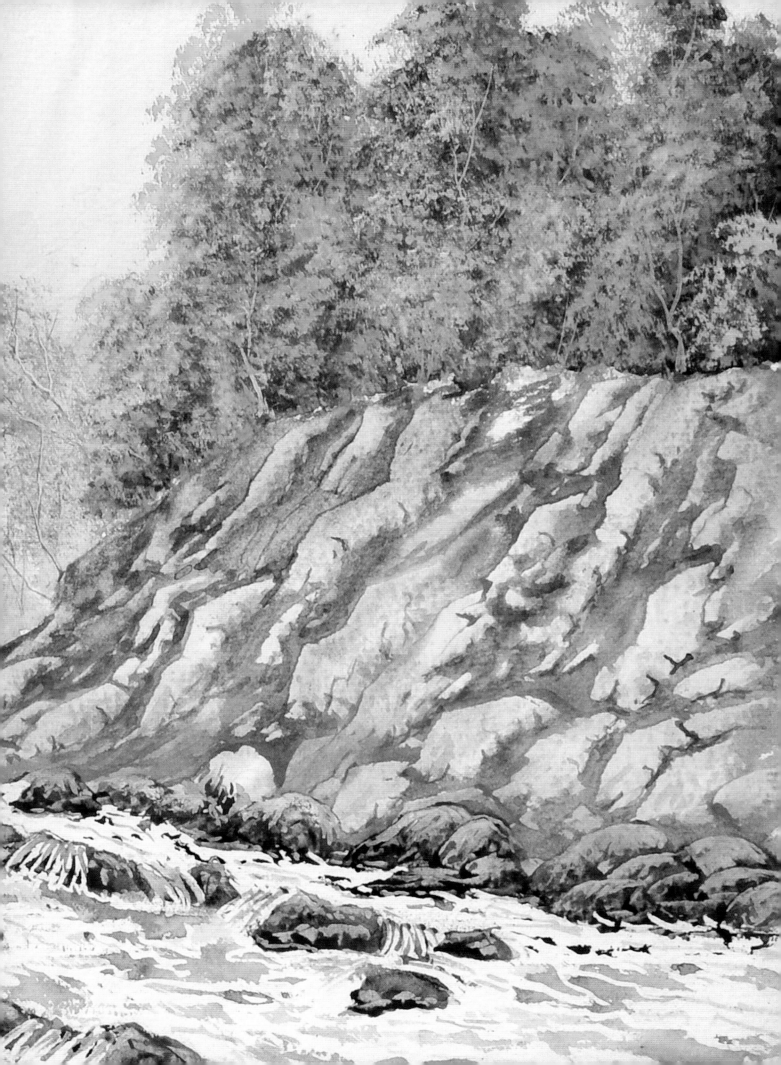

River Esk

A pleasing winter scene providing the opportunity to capture snow-covered mountains. There are lots of rocks in the painting – note the variety of shapes and sizes and how the water runs between them. This is a more challenging landscape to capture in paint.

TRACING
5

You will need

300gsm (140lb) rough watercolour paper, 44.5cm x 32.6cm (17½ x 12¾in)

20mm (¾in) masking tape

Masking fluid

Dark brown water-soluble crayon

Colours: Payne's gray, cobalt blue, alizarin crimson, raw sienna, burnt sienna, titanium white acrylic

Brushes: Sky and Texture brush, size 14 round, Derwentwater and Ullswater brushes, size 6 rigger, size 3 rigger, 20mm (¾in) flat

Keith Fenwick's Wonder Knife

Paper tissues

1 Transfer the tracing to the paper as described on page 9, then secure it to a board with masking tape. Use the Sky and Texture brush to paint the background sky with dilute cobalt blue.

2 Drop in a little alizarin crimson wet-in-wet to vary the sky colours.

3 Use the size 14 round to add a little alizarin crimson near the top of the mountains while the wash is still wet.

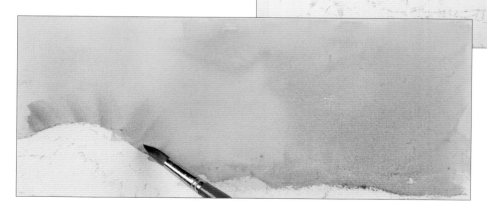

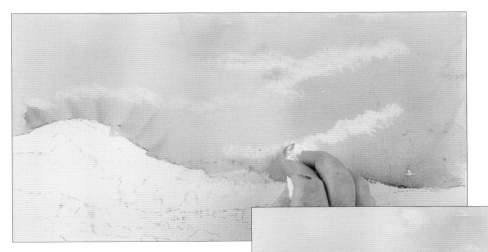

4 Lift out some clouds using a clean dry tissue.

5 Position some 20mm (¾in) masking tape across the horizon line. Do not lay it on too straight, but suggest a varied horizon.

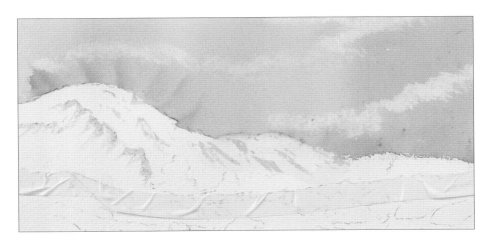

6 Paint in the snow-capped mountains, using the size 6 rigger with dilute cobalt blue. Dab the paint on with the tip, then draw it out into broken dots and dashes with the side of the brush. Less is more, so do not overdo this stage!

7 Work around the top of the mountain with a darker mix created by adding a little Payne's gray to the mix.

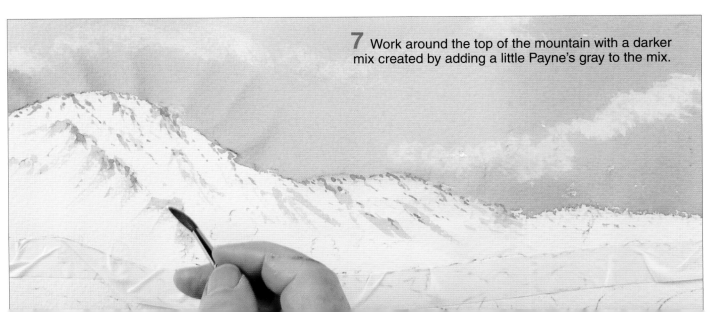

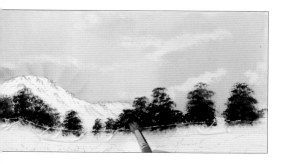

8 Swap to the Derwentwater brush and use a mixture of burnt sienna and Payne's gray with a touch of alizarin crimson to dab in the trees along the horizon line. Vary the mixes for variation and allow to dry.

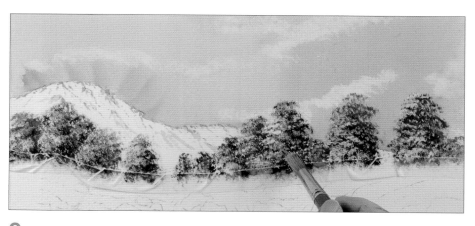

9 With the Derwentwater brush, lightly stipple titanium white acrylic on the distant trees to create the impression of snow.

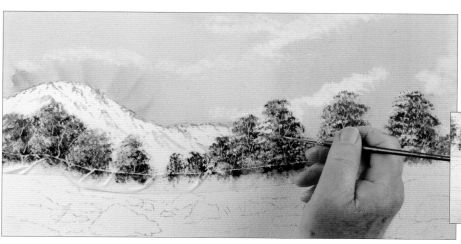

10 Using the size 6 rigger loaded with some titanium white acrylic, paint in some tree structures, then carefully remove the masking tape (see inset).

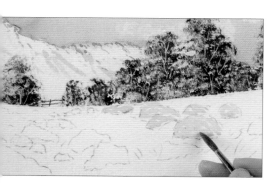

11 Use the size 3 rigger with a mix of Payne's gray and burnt sienna to indicate some distant fenceposts in the gaps between the trees and bushes, then swap to the size 6 rigger and apply a wash of raw sienna to the clump of rocks on the right-hand bank.

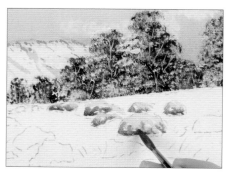

12 Drop in burnt sienna wet-in-wet around the base of the rocks.

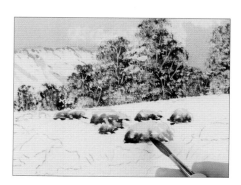

13 Add depth to the rocks with a mix of Payne's gray and alizarin crimson applied to the bases. This creates a three-dimensional effect.

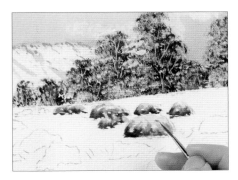

14 Switch to the size 3 rigger and tease the wet paint around the shapes, encouraging the colours to blend together.

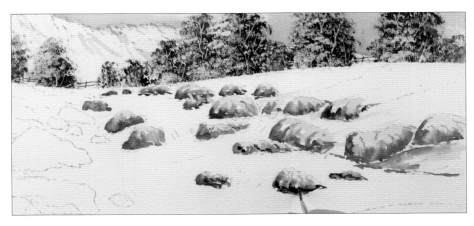

15 Paint the other rocks on the right in the same way.

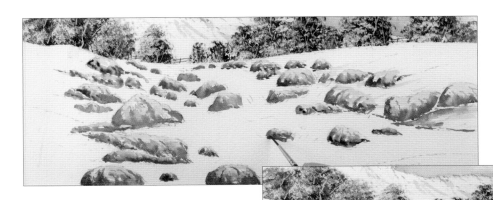

16 Continue until all the rocks are painted in the same way.

17 Using the side of the size 14 round, mix a little Payne's gray into cobalt blue and twitch up some light strokes on the snowy banks to create shadows.

18 Use the Ullswater brush to create a mix of burnt sienna and Payne's gray. Use the chisel tip to stipple in stubble and details on the banks to signify the lay of the land. Add more Payne's gray and repeat the process to add depth to the stubble.

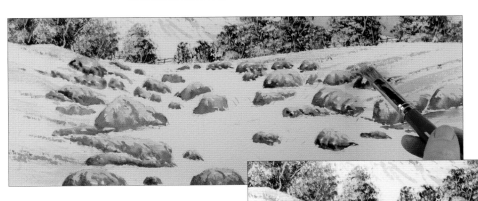

19 Split the size 14 round brush into a fan with your fingers (see page 12), and use a mix of burnt sienna with a touch of Payne's gray to add a few patches of tall grass, using an upwards flicking motion.

20 Turn the brush over and add some flecks to the snow in the foreground with the same mix.

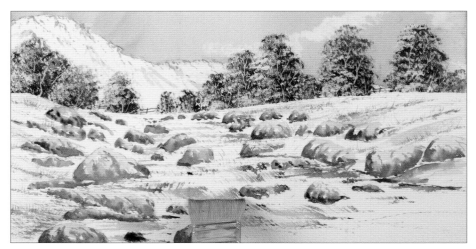

21 Using the Sky and Texture brush with a mix of cobalt blue and Payne's gray, paint in the water, using light touches to leave some of the white paper showing through. Work from the distance to the foreground, using the corner of the brush to work a deeper mix of the colour into the areas closer to the banks.

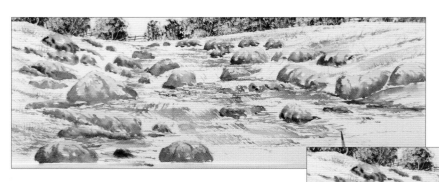

22 Create some horizontal ripples in the water with a darker mix of the same colour and the size 3 rigger.

23 Add in the areas where the paint falls over the rocks with diagonal strokes using the same brush and mix.

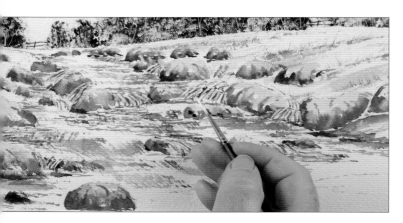

24 Use titanium white acrylic to paint in some highlighting strokes in the same areas.

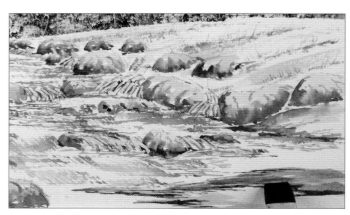

25 Apply a raw sienna wash to the foreground on the right-hand side using the 20mm (¾in) flat, adding burnt sienna wet-in-wet to vary it, and Payne's gray for definition at the edges.

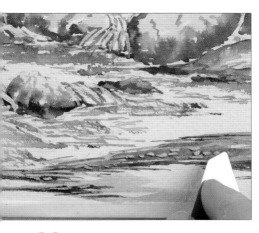

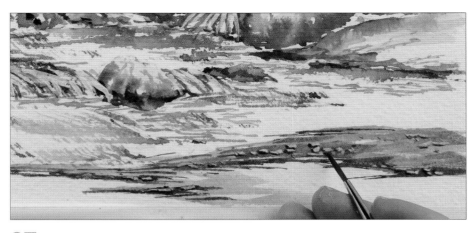

26 While the paint is wet, use the Wonder Knife to create the suggestion of a few pebbles.

27 Add shadows to the pebbles with the size 3 rigger and a mix of Payne's gray and burnt sienna.

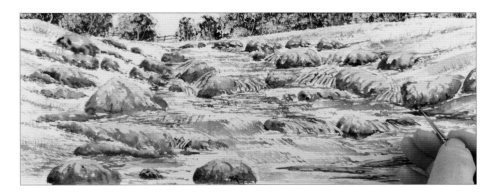

28 Add some more structure to the rocks with the same mix, then add some details across the foreground with the rigger and the mixes on your palette.

29 Paint some snow on top of the rocks using pure titanium white and the size 3 rigger.

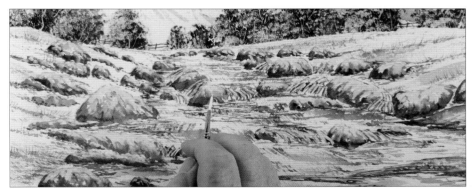

30 Add some burnt sienna touches near the bases of the rocks with the size 3 rigger, then allow to dry and remove the masking fluid to finish.

Overleaf

The finished painting.

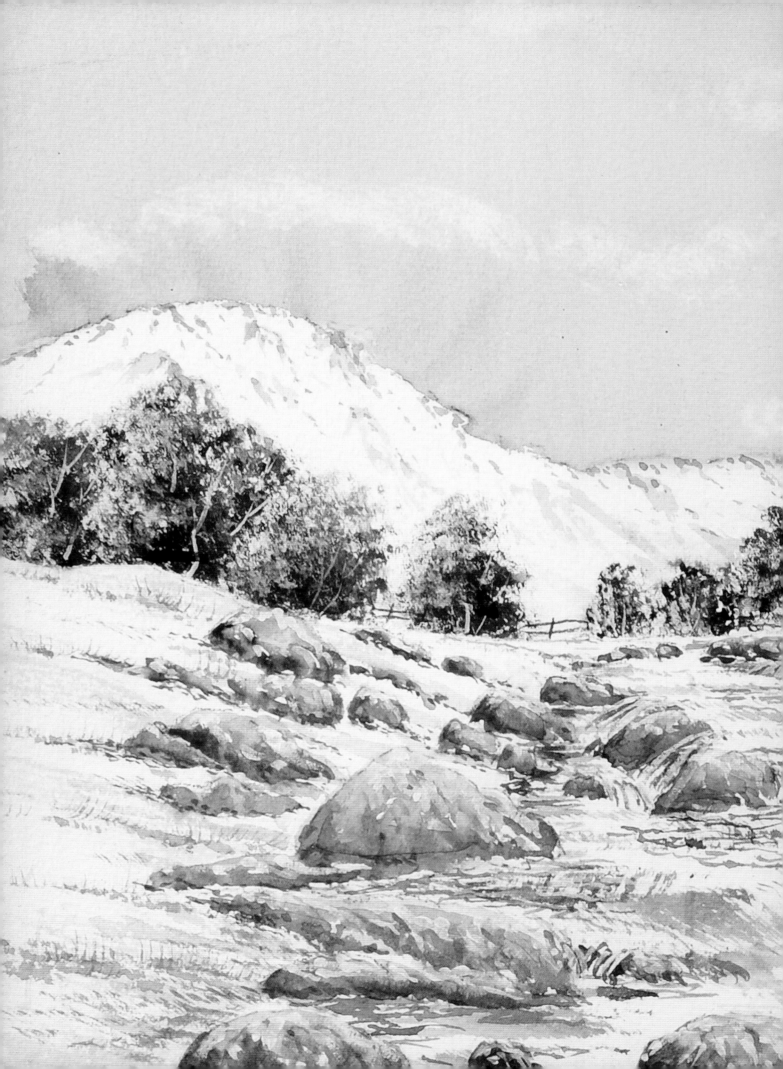

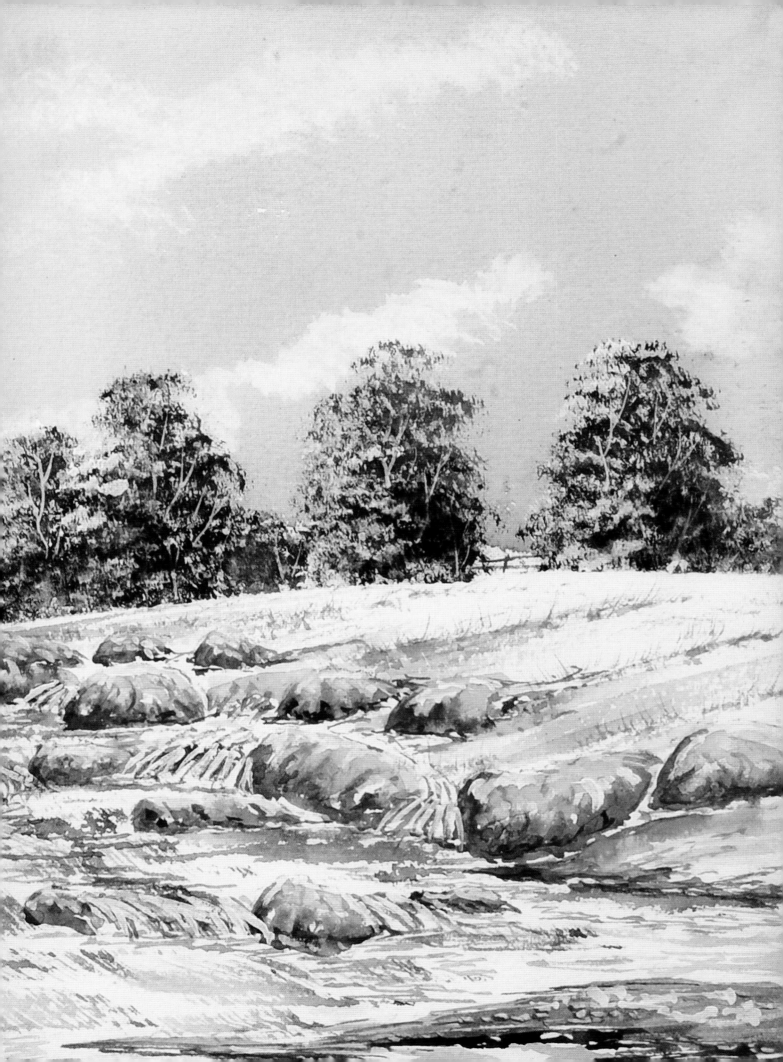

River Wear

A calm and pleasing composition, providing an opportunity to practise mixing the wide range of greens in this landscape. The reflections are subtle and enhance the painting, while a simply painted fence improves the overall effect. Notice the depth of shadow in the trees – this is very important for realism.

You will need

300gsm (140lb) rough watercolour paper, 44.5cm x 32.6cm (17½ x 12¾in)

20mm (¾in) masking tape

Dark brown water-soluble crayon

Colours: Payne's gray, cobalt blue, alizarin crimson, raw sienna, burnt sienna, sap green, cadmium yellow, titanium white acrylic

Brushes: Sky and Texture brush, large stippler, size 14 round, 20mm (¾in) flat, Derwentwater and Ullswater brushes, size 3 rigger

Keith Fenwick's Wonder Knife

Paper tissues

Tip

If nature is pleasing, attempt to copy it; if not, attempt to improve it.

1 Following the instructions on page 9, transfer the image to the paper, then secure the paper to the board with masking tape. Secure some more masking tape across the horizon. This will ensure your waterline remains level.

2 Wet the sky with clean water using the Sky and Texture brush. Drop in a little raw sienna and cadmium yellow in the centre, then drop in cobalt blue wet-in-wet over the rest of the sky.

3 Drop in cobalt blue wet-in-wet (see inset), then lift out some clouds with clean dry tissue, using a dabbing action.

4 Allow the paint to dry and then re-wet the sky. Drop in more cobalt blue to reinforce and enrich the sky, lifting out clouds as before.

5 Paint in the distant trees with a blue-green mix of cobalt blue, sap green and a little touch of titanium white acrylic. Apply the paint with the Derwentwater brush and a stippling motion. Add a little Payne's gray to the base of the treeline and allow the paint to dry.

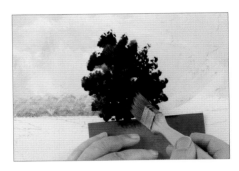

6 Carefully remove the masking tape from the horizon, then use the large stippler with a mix of sap green and Payne's gray to paint in the large tree on the right. Hold a piece of card as a mask to control the flow of paint at the base of the tree.

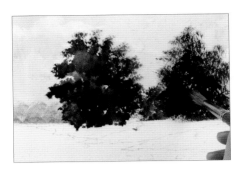

7 Use the Derwentwater brush to shape the tree using a slightly drier version of the same mix. Add in the small bush and large tree to the right with the same mix and brush. Allow the paint to dry thoroughly.

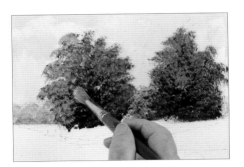

8 Using the Derwentwater brush with a mix of cadmium yellow and sap green with a hint of titanium white acrylic, add in the representation of foliage with a light stippling action. Use more cadmium yellow on the small bush in the middle, and more sap green on the tree on the right.

Note

The reason I am using white acrylic paint mixed with the watercolour, rather than gouache, is that fifty per cent of gouache deposit will soak into the underpainting, whereas with acrylic mixed in, the paint will all stay on the top, creating more sparkle to the foliage.

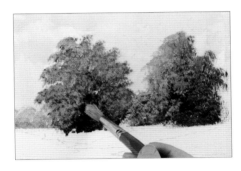

9 Add titanium white acrylic to the mixes and use these to highlight the trees.

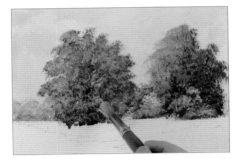

10 Break up the tree group with some smaller bushes in front of them using the same mixes, but with still more titanium white acrylic added.

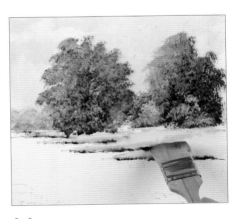

11 Lay in the grass area with the Sky and Texture brush and cadmium yellow. Add more sap green to the mix and drop in touches wet-in-wet. Edge the riverbank with Payne's gray while the paint is still wet.

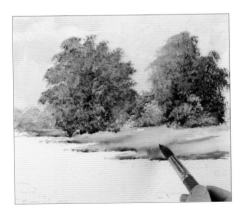

12 Using the size 14 round brush, twitch the colours together to create a soft, natural effect in the grass.

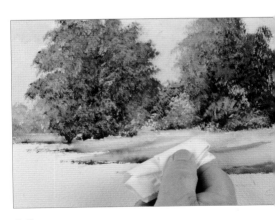

13 Fold some tissue into a wedge and wipe a little excess paint from the grass to soften aspects.

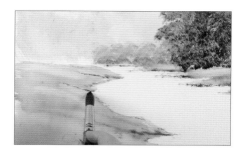

14 Paint the grassy area on the left in exactly the same way, adding a little burnt sienna on the banks. Allow to dry.

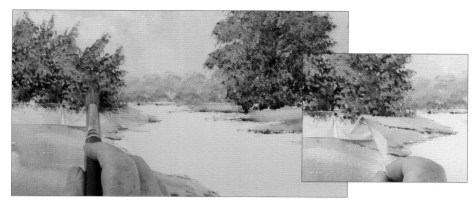

15 An alternative to using the card mask is to position masking tape over the top of the grass. Paint in the trees on the left as before, then remove the masking tape carefully (see inset).

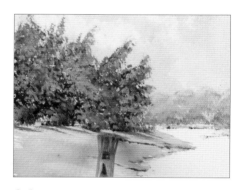

16 Using the Ullswater brush, add some shadows under the trees with a stippling action and a combination of sap green and Payne's gray.

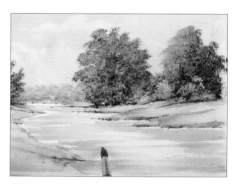

17 Make a dilute mix of cobalt blue with a hint of sap green and use the size 14 round to lay in the water with quick horizontal strokes.

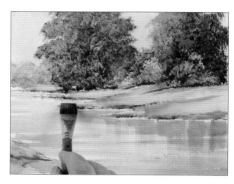

18 Hold the 20mm (¾in) flat brush nearly flat against the paper and draw down mixes made from sap green, cadmium yellow and raw sienna.

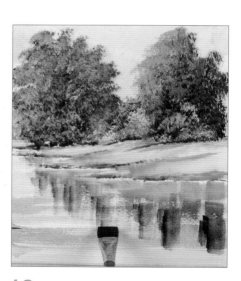

19 Add vertical strokes of a sap green with Payne's gray mix to create the darkness reflected from the trees.

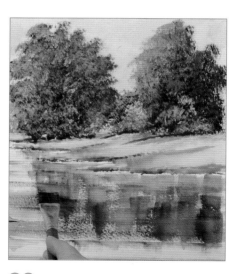

20 Use a mix of cadmium yellow and titanium white to add vertical strokes to represent reflections of the light areas in the trees. Turn the brush on its side and draw the wet paint horizontally with smooth lines.

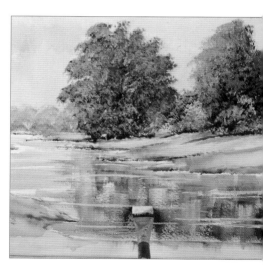

21 Add some horizontal strokes of titanium white acrylic using the edge of the 20mm (¾in) flat.

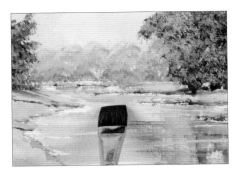

22 Using a little dilute cobalt blue, add a subtle reflection of the trees at the horizon.

23 Start to suggest some rocks using the 20mm (¾in) flat and burnt sienna. Add Payne's gray and alizarin crimson to vary the colour and shade them, then use the Wonder Knife to add detail.

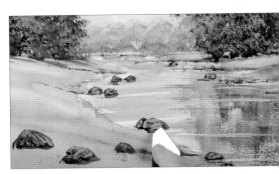

24 Add more rocks on the other side of the river in the same way.

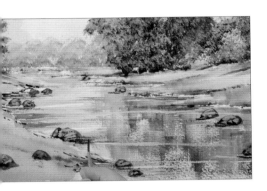

25 Pick out the edge of the riverbank with the size 3 rigger and a mix of Payne's gray and burnt sienna. Add depth to the water's edge with horizontal strokes of a Payne's gray and alizarin crimson mix.

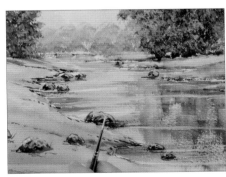

26 Add more structure and detail to the rocks with the size 3 rigger and a mix of Payne's gray and burnt sienna, then add highlights with titanium white.

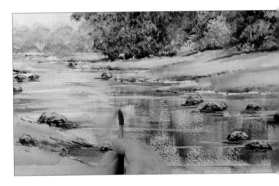

27 Use the size 6 rigger brush and dilute titanium white acrylic to soften the edges of the reflections of the trees.

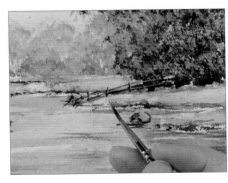

28 Using the size 3 rigger brush, with a mix of Payne's gray and burnt sienna, paint a fence coming down from the large tree on the right-hand side to the water's edge. Highlight the fence with titanium white added to raw sienna.

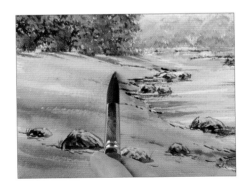

29 Using the size 14 round brush, add darker tones to the left-hand bank with a sap green and cadmium yellow mix. Add a pure cadmium yellow glaze to the grass to give it warmth.

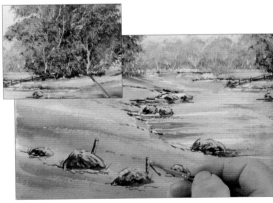

30 Use titanium white acrylic with a little raw sienna added to paint in the trunks and main branches of the trees with the size 3 rigger (see inset), then add in the foreground fenceposts with a mix of Payne's gray and burnt sienna, highlighted with a titanium white and raw sienna mix.

Overleaf

The finished painting.

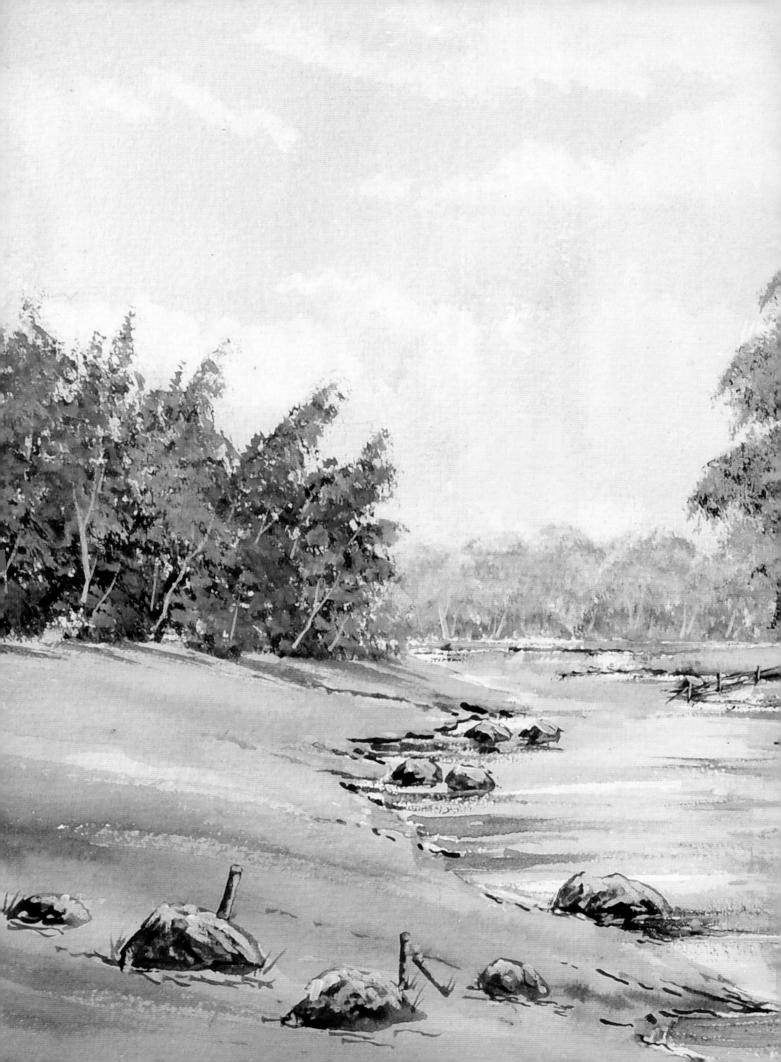

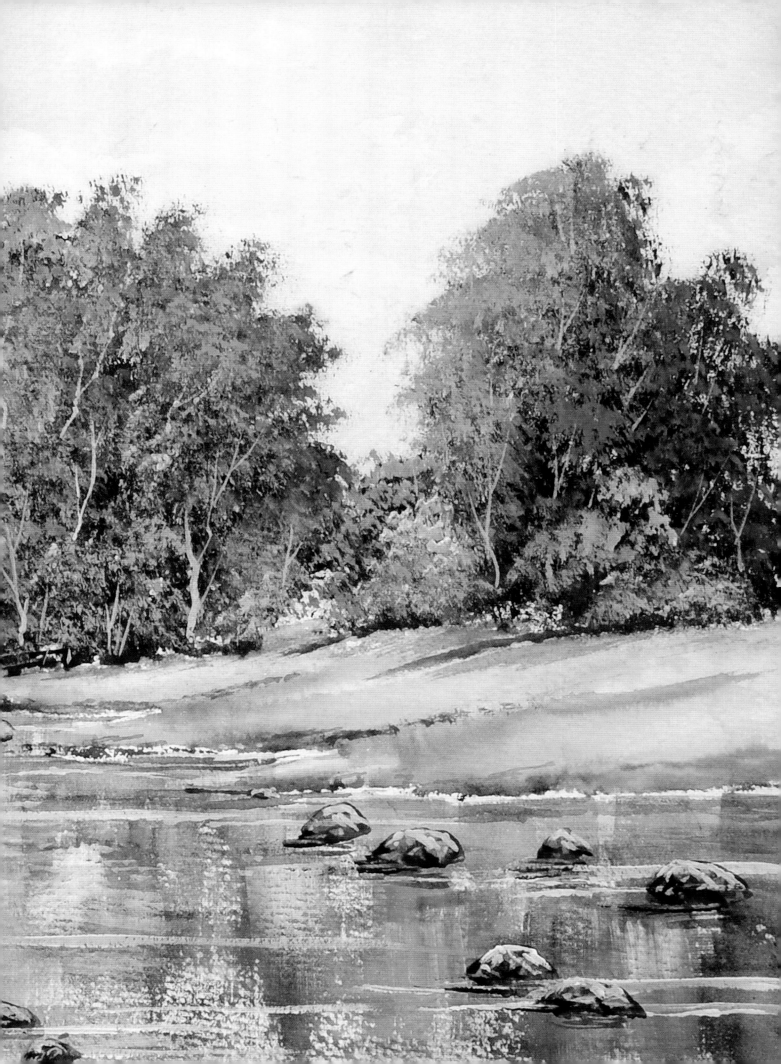

Index

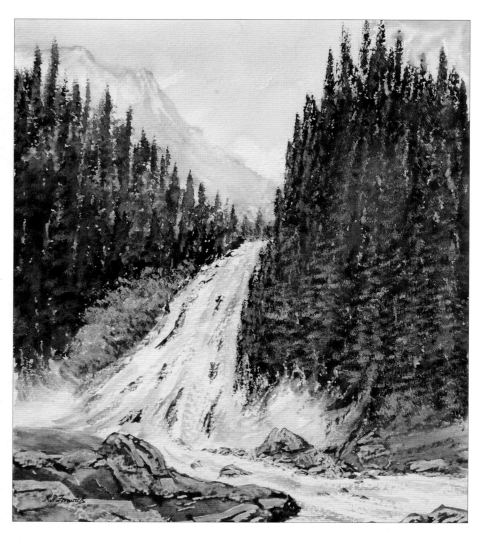

Krimml River and Falls, Austria
30.5 x 35.5cm (12 x 14in)

This spectacular fall, where the Krimml River thunders down nearly 380m (1250ft) in three stages, is at the foot of the Gerlos Pass and provides an impressive landscape to paint. I sketched it while on holiday and finished it in the studio.